A HISTORY

of

White Hall

A HISTORY
of
White Hall

HOUSE OF CLAY

LASHÉ D. MULLINS
and CHARLES K. MULLINS

THE
History
PRESS

Published by The History Press
Charleston, SC 29403
www.historypress.net

Copyright © 2012 by Lashé D. Mullins and Charles K. Mullins
All rights reserved

Cover images courtesy of Kentucky Department of Parks and Liz Thomas Photography.

First published 2012

Manufactured in the United States

ISBN 978.1.60949.313.4

Library of Congress CIP data applied for.

This book is dedicated to our children, Charles Gabriel Marcellus Mullins and Evelyn Haven Gail Mullins. It is also dedicated to all those who have loved White Hall and have made it a part of their lives. Like Cassius M. Clay, they also can proclaim "Quorum pars fui"—of them I was a part.

CONTENTS

PREFACE

I began my employment at White Hall State Historic Site in 1995, but my history with the place goes much farther back. My uncle manages the Bennett farm that surrounds the park, and when visiting my relatives as a young girl, I would glance eastward toward the brightly lit structure and wonder about the people who once lived there. Later, my family would move to the Bennett farm, and I could then gaze out of my own bedroom window at the house any time I wanted. Throughout the years, I had many relatives work at White Hall, and I would visit the park whenever I got the opportunity. White Hall has an annual event in October called *Ghost Walk*, for which the park partners with Eastern Kentucky University (EKU) Theatre to perform a production based on the Clay family's life. When I began college in 1994 at EKU, I felt privileged to be cast in this production. The experience was such a good one that I rode out to the park the following spring with a fellow theatre student who had worked at White Hall the previous year, and who had also performed in *Ghost Walk*, to apply for a job. I was blessed with a summer position.

Near the end of that first year, I remember that friend asked me how I liked working at White Hall, to which I replied, "It's fun, but I won't be back next year." That was eighteen summers ago, and I have yet to be fully able to separate myself from the place. Upon graduating, I applied for a full-time position as curator, a title I have held since 1999. The young man with whom I had initially applied for a job married me on the steps of the mansion in that same year. In 2003, we moved to the park, and our children are able to run around and play in one of the loveliest backyards in Madison County.

Words cannot completely express what White Hall means to me. This house, this park, is not just a job for me—it is my life. A wise person once said, "Choose a job you love, and you will never have to work a day in your life." Not necessarily so, as there has been a great deal of work involved over the years, but it has always been varied, rewarding and joyful. I honestly feel like one of the luckiest people around to be able to call this place home.

Because new information about the Clay family and the house is found almost on a daily basis, this book can never really be complete. In fact, I fully expect some great epiphany to occur right after the work is published. If I had been able to tell all that is known about this special place and the fascinating people associated with it, this book would be the size of a dictionary. Therefore, I had to pick and choose what I would share and what I would leave out. I hope the reader will enjoy the history as much as I do; it is a pleasure and an honor to be able to share it.

–Lashé D. Mullins

My first knowledge of White Hall goes back to the early 1990s. In the fall of 1993, I was an undergraduate student at Eastern Kentucky University majoring in speech communication and theatre arts. One day, a professor approached me about performing in a play at a local museum. I would learn that the museum was actually a state historic site, and the play was essentially a composition of scenes and monologues, mostly based on a man named Cassius M. Clay and his illustrious family.

I recall being part of a caravan of student actors trekking out to White Hall for the first time. It was nearing sundown, and as my carpool approached our destination, I remember feeling excitement and anticipation. Suddenly, after seeing nothing but a landscape of farmland and cattle out of the car window, I saw it for the very first time. I was in awe of the sheer grandeur of the mansion. I had never seen a house quite like it. It was truly love at first sight. The museum and the history made such a lasting impression on me that when that theatrical production ended, I approached the manager of the site about the possibility of a summer job. I was employed as a docent in the summer of 1994 and returned for many seasons to follow.

It was during my second season of employment in 1995 that I became good friends with a young woman named Lashé Dunn. Like me, Lashé had developed a special love for White Hall. In the not too distant future, I

developed a special love for her as well. Lashé and I share a connection to White Hall that is difficult to describe in words.

I think back to that cold October night when I first visited "the Big House." I had no idea that twenty years later, I would be living at White Hall with my wife and that we would be raising our children on its beautiful grounds. I'm eternally grateful for everything White Hall has given me over the years.

–Charles K. Mullins

Acknowledgements

William McKay from The History Press, without whom this work would not have become a reality. Many thanks for all of the encouragement and advice on the project and for allowing us this wonderful opportunity.

Kathleen White, park manager of White Hall State Historic Site, who gave endless support, suggestions and numerous days off work to complete the book.

Jeffrey Boord-Dill, theatre instructor, director, tour guide extraordinaire and fountain of knowledge in all things Clay, who provided interesting tidbits and recommendations for the book and spent many hours editing the work.

Mack McCormick at the University Press of Kentucky and Jim Birchfield from the Warwick Foundation, for their generous permission to use Clay Lancaster's floor plans of Clermont.

Jim Holmberg from the Filson Historical Society, for assistance with transcriptions of and permission to use General Green Clay's January 8, 1820 letter housed in the Green Clay Papers of Filson's collection.

Elizabeth Thomas, for her fabulous photographic work and attention to detail on the modern images in the book.

Paula White, for her insightful interview and remarkable enthusiasm. Thank you for traveling back in time with us.

James M. Cox, for the generous use of his photographs and his wife's information on the Richmond Garden Club, as well as the wonderful visits he made to White Hall, entertaining us with boundless recollections of his life and the mansion before restoration.

Helen Chenault, for the delightful conversation about White Hall and her firsthand experiences with the Richmond Garden Club.

Judy Ballinger King, for her recollections of the mansion while she and her family lived there and for the use of the photograph of her family and friend on the steps.

Lynn Daniels, for helping us contact her cousin, Judy Ballinger King, and her immense interest in White Hall.

INTRODUCTION

At the end of a short winding country road in Madison County, Kentucky, on the southeastern edge of the Bluegrass Region, past gently rolling farmland, an impressive brick Italianate mansion seems to appear out of nowhere. By day, basking in the warmth of the sun, it is a towering building full of historical and architectural wonders, beckoning guests to step inside. By night, amid a crawling fog, it is a mysterious and slightly sinister structure luring the curious and thrill seeking. Once a home and showplace for a great family and now a tribute to a patriarch and a lifestyle long gone, this is White Hall. This is its story.

PART I

CLERMONT

By Wisdom a House Is Built

*By wisdom a house is built, and by understanding it is established; by
knowledge the rooms are filled with all precious and pleasant riches.
—Proverbs 24:3–4, English Standard Version*

Behind every great historic structure are the people who built it. More
than likely, the land that encompasses White Hall State Historic Site
today would be a subdivision of cookie-cutter houses, with no trace of
history, if it hadn't been for one man: General Green Clay. He was the
great-great-grandson of Captain John Clay, who sailed in February 1613
from Wales across the great pond to Virginia on the ship *Treasurer*.[1] Known
as the "English Grenadier," originally John and fifty of his men came to
America to "protect" the Virginia settlers. Captain Clay had a change of
heart, however, and turned over a new leaf (or turned coat, depending on
what side you're looking at); he resigned his post, obtained some land and
settled down to family life.[2] About 145 years later, Green Clay was born in
Powhattan County, Virginia, on August 14, 1757.[3] Green was one of eleven
children, blessed with his unusual first name by his mother, Martha Green.[4]

Based on a painting of him, it appears that Green had blue or light gray
eyes, with dark hair that went gray as he got older. Green stood at five
feet, eleven inches and, according to one account, "was more robust than
elegant in person."[5]

According to family lore, Green Clay had a little bit of a tiff with dear old
dad, Charles Clay,[6] and although still considered a minor, he decided to "go
west, young man"—in this case, to Madison County, Kentucky. It's possible

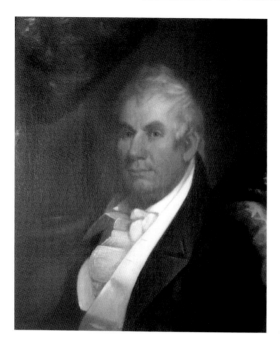

Portrait of General Green Clay, believed to have been painted by artist Matthew Harris Jouett. *Courtesy of Kentucky Department of Parks and Liz Thomas Photography.*

that tales of Daniel Boone roused in Green a thirst for adventure that led him to the Bluegrass State.[7]

Although credited with only having a total of nine months of schooling in regards to math, Green Clay's "grasp of a subject was quick and comprehensive,"[8] and he apparently had enough smarts to learn land surveying. One contemporary account noted that he would ride around on a mule dressed in buckskin pants and a hunting shirt.[9] Perhaps his attire threw people off, or it might have been that Clay was a natural-born actor. Legend has it that while traveling the great Kentucky frontier, Green ran across fellow surveyors. When they asked if he understood mathematics, Clay replied, "I knew one George Mattox." Who knows if Clay was joking or trying to pull one over on the men. In any event, his fellow surveyors took the answer to mean that Green wasn't the brightest bulb in the pack, so they employed him as their cook and cabin keeper. The joke was on them. After his companions completed their survey, Green copied their paperwork and high-tailed it back to register the property three days before they even got started, entering the land as his own.[10] As it has been said, "There's a sucker born every minute."[11]

All of Green's hard work and shady double-dealings paid off; by 1792, he had been chosen as an official deputy surveyor.[12] At times, Green was able

to claim up to half of the land he surveyed as payment for his services. Mr. Clay liked his land, and he was never one to pass up an opportunity to add more acreage to his ever-growing collection. Clay was so proficient at this vocation that by the time of his death, he was arguably the largest landowner in the Commonwealth of Kentucky.

With all that land, Clay was able to raise tobacco and sell his crops in warehouses he owned.[13] Tobacco may have been a good cash crop at the time, but Green determined at an early point that the plant took too many nutrients from the soil and eventually ceased producing it on his estates.[14] Clay also grew rye and wheat in his numerous fields,[15] for which his gristmills sold the flour. Clay was the owner of several taverns and provided the spirits for those establishments from his own distilleries, produced by corn that he grew on his properties.[16] Green was even the proud owner of a resort—how's that for entrepreneurship?[17]

By the mid-1790s, Green Clay had become a magistrate of the court.[18] This post was extremely beneficial to him in that he was able to rake in more land and money by being in such an esteemed position. Clay oversaw the settling of estates (old man Wilson had just died, and he doesn't need that land anymore, so I'll just take a chunk). He had the authority to sanction the localities and the rights for area roads (we need a toll road in this area, so I'll just have it go directly through my land) and businesses such as gristmills and warehouses (this is a great area for this type of business, so I'll put one of mine here). He could appoint individuals as inspectors (I'll select my good friend Thomas Watts as tobacco inspector, and he'll look the other way when I need him to),[19] and he was able to set the going rate for area taverns, local ferries and neighborhood turnpikes, some of which were owned by him personally.[20]

Making money took a lot of time, but so did keeping it. It seems that a great portion of that time was spent in court. Clay was known for going to court over nearly anything, and the majority of the time he won. Now and then, his motives tended to be a little on the questionable side. He once went to court to resolve a debt owed to him by a gentleman by the name of William Ranold, who had the misfortune to die before settling with Clay. Although the amount owed to Green was a small one, Green felt that Ranold's acres would correct the problem, so he sued Ranold's heirs, described in the court records as "two infant females." Not surprisingly, Green won the case.[21] When it came to his property, Green didn't even mind taking little girls to court to get what he thought was his due.

Green also spent some time in court for his dubious practice of carving his initials or his name on landmarks, such as rocks and trees, to give other

surveyors the impression that he owned them. In reality, Green didn't own this land, but won the case and was granted the right to go back and actually survey this land and gain possession of it.[22] Green's antics in court were so well known that one land grant issuer informed his subordinate to go ahead and approve Green's land grants no matter how illegal they appeared because Green would just end up filing a grievance in the court of appeals and acquiring the land anyway.[23]

Clay's duplicity caused a bit of a commotion in 1817. Green had acquired court consent to have a ferry travel from his own land across the Kentucky River to land owned by a man named William Bush. Green Clay had acted as an attorney for the heirs of Bush, who in turn granted him the permission. It turned out that the heirs Clay represented weren't the real heirs, and the lawful beneficiaries took him to court for "fraudulent design" by trying to "gain possession" of their land. While the plaintiff's attorney was out of town, Clay and his court buddies ruled against the Bush heirs. Although this court case was controversial, in the end Clay got what he wanted.[24] It's good to be the king.

Another time that Green got into a little bit of trouble was for distributing free turkeys to the local people. On any normal day, one would think that Green was just a generous guy, looking out for the well-being and stomachs of his fellow man, much like Dickens's Scrooge and his Christmas goose. However, the doling out of the tasty birds occurred on election day. Although compatriots might think more kindly of Green when they went to the polls with a full belly, his political adversaries cried foul on the fowl.[25]

In addition to crops produced on his extensive lands, Green also raised and sold numerous varieties of domestic animals, possibly including the aforementioned turkeys. It was sheep, however, in which he had the most vested interest—particularly Merino sheep, which he had imported into Kentucky and continued to raise until his death.[26] Clay oversaw the benefits of this enterprise, from the importation to the wool production (he had a loom house on his own estate),[27] as well as the knowledge of how to properly butcher the animals. Apparently, he placed great stock (pun intended) in mutton soup for its nutritional value and its abilities to cure the sick. To describe just how great Green Clay's interest was in this venture, his youngest son, Cassius M. Clay, stated in his *Memoirs* with regards to his father, "He was a great lover of sheep."[28] Whether this love was his appreciation for what this type of livestock could provide nutritionally and financially, or for other reasons that the authors won't go into, we'll let the reader decide.

When discussing Green Clay's wealth, it would be impossible to not mention the enslaved individuals whom Green owned. As distasteful as it

may seem to modern readers, Green Clay had a vast enterprise in regard to the slave trade. In order to generate all the wealth that his lands were producing, workers were needed, and slaves were the most profitable workers to be had. Green was all about profit.

In his *Memoirs*, Cassius M. Clay briefly mentioned how his father dealt with his slaves:

> *Now slavery was a terrible thing; but he made it as bearable as was consistent with the facts. When any of the slaves were found to "play the old soldier," and pretended to be sick, he had a fine medicine in the bark of the white-walnut. This he would have mixed with much water. If the patient was really sick, it was a safe and excellent remedy for many diseases; but, if he was playing "possum," he would go to work rather than swallow the bark. There was no market for sheep in those days; and my father's object of raising large flocks was to clothe his slaves well. He always had the heaviest cloth made for men and women, and then "fulled." By this operation the web was thickened, and made, like the felting of wool-hats, water-proof. He used to say: "Better lose the value of a coat than that of the workman." He fed and sheltered his slaves well, allowing them gardens, fowls, and bees. Groups of cabins were far apart for pure air. No man understood better how to manage his dependents. He provided first-class clothing, food, and shelter for his slaves; but always was rigid and exacting in discipline. Of all the men I ever knew, he most kept in view the means which influenced the end.[29]*

Green Clay's will had 105 slaves listed, all by name, making him possibly the largest slaveholder in the state of Kentucky at the time of his death. Of them, 84 slaves were given, either in trust or outright to his children; 1 slave was given to his wife, with stipulations attached; 12 slaves were emancipated; and 8 were sold.[30]

With all of Green Clay's diligence in building an empire, it is astonishing that he found the time to get married and have children, but he somehow managed it. Clay chose for his bride Sally Lewis, the daughter of Thomas Lewis and Elizabeth Payne, a very prominent family who hailed from Lexington, Kentucky, by way of Virginia. Sally's father played a major role in politics, being a magistrate like Green, as well as a member of the First Kentucky Constitutional Convention. Another claim to fame for Thomas Lewis was that he administered the oath of office to the first governor of Kentucky, Isaac Shelby.[31] Green Clay married into this influential family on

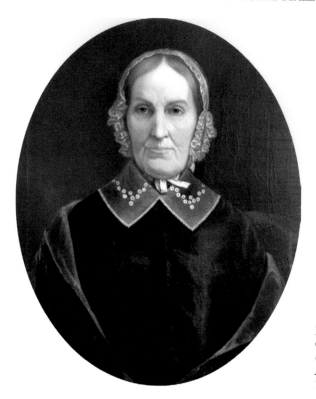

Portrait of Sally Lewis Clay, artist unknown. *Courtesy of Kentucky Department of Parks and Liz Thomas Photography.*

March 14, 1795. Ms. Sally was nineteen years his junior, having been born on December 14, 1776.[32]

Green was as successful building his family as he was his empire. Green and Sally had seven children together from 1798 to 1813: Elizabeth Lewis Clay Smith (March 29, 1798–October 14, 1887), Sidney Payne Clay (July 16, 1800–July 2, 1834), Paulina Green Clay Rodes (September 7, 1802–December 15, 1886), Sally Ann Clay Irvine Johnson (September 24, 1804–October 23, 1829), Brutus Junius Clay (July 3, 1808–October 11, 1878), Cassius Marcellus Clay (October 19, 1810–July 22, 1903) and Sophia Clay (March 3, 1813–July 8, 1814)—three boys and four girls, with the youngest child, Sophia, the only child not to survive into adulthood.

Of course, Green was far too busy to have much to do with his children other than to father them. Green Clay's youngest son, Cassius, mentioned that Green was "a stern man, absorbed in his affairs. He spent but little time with the children, and did not assume control. Yet he directed, in the main, what was to be done."[33] Cassius went on to state, "I saw but little of my father; he was always absent, and when at home was engaged in business."[34]

Green may have been stern, but he did have his soft side. Cassius also mentioned that Green "would never allow children to be awakened; but left them, under all circumstances, to sleep on till they awoke of themselves."[35]

Based on Clay's *Memoirs*, it would appear that their mother, Sally Lewis Clay, as well as the Clay family slaves, primarily raised the Clay children. Although frequently away on business, Green had his influence on his progeny, making sure that they (or at least the boys) were educated and directing them in certain moral areas, as he would not allow his children to play cards or drink alcohol.[36] This last moral value made an impression on young Cassius, as he recalled watching his father every morning go to his liquor chest and take out a bottle of bourbon. From this bottle, Green would take one medicinal swig per day before breakfast. All the while engaged in this necessary evil, Green would look at his male offspring with a remorseful face, as if the dose was almost too much for him to bear. Cassius, being a curious sort of child, wondered: if it was good for his papa, why wasn't it good for the children? Taking a drink on the sly, Cassius found that the "medicine wasn't really all that bad tasting." Lucky for Cassius, alcoholism was not a weakness as "the Bourbon itself was not fascinating."[37]

Not a great deal is known about Mrs. Sally Lewis Clay. What little information there is established has been gleaned from letters of the time written to or from Sally, a handful of court documents and what her youngest son wrote about her in his *Memoirs*: "My mother was Calvinist in faith, and, though not believing in good works as the ground of salvation, yet was the most Christian-like and pious of women in every word and thought. With her truth was the basis for all moral character. She would not tolerate even conventional lies, never saying, 'Not at home' to callers; but, to the servants, 'Beg them to excuse me.'"[38] This characteristic of his mother would influence Cassius all his life, even in regards to his pro-emancipation views on slavery: "This it was, when I was asked, in order to corner me, if slavery was not a good and Christian institution?—considering all the consequences, remembering her who had given me life and principles to live or die by—that led me to answer No!"[39]

In disciplining her children, Cassius stated that his mother was "not a woman to be trifled with." She was very decisive and swift. Mrs. Clay was a firm believer in corporal punishment. Although known for his fighting skills when he got older, the young Cassius was no match for his mamma. Cassius M. Clay stated that his mother whipped him twice in his lifetime, once for fighting with the overseer's son and the second for lying. On his second offense, Cassius was ordered to come to his mother for punishment.

Having been punished with a "rod" from a peach tree, which Sally had not "spared," Cassius knew what was coming and instead ran away from his mother. The house and kitchen slaves chased after him. Cassius situated himself on a pile of rock and fired stone missiles at anyone who came near him. As he put it, "For, as I had been whipped for fighting, now I fought not to be whipped."[40] Finally, his mother had to take matters into her own hands and came to get young Cassius herself. Cassius then resigned himself to his punishment, stating that "when I found escape neither in running nor in fighting, I ever after submitted with sublime philosophy to the inevitable."[41]

Thus far we have established that Green Clay had a very strong head for business and was a mostly absent but loving father. What other traits did he possess? Although one can make speculations on Green's character based on court records of the time, one of the few documents in existence today that gives any kind of window into Green's personality was written by Cassius in his own *Memoirs*. There is little doubt that Green was a courageous man. When called upon, he served his country in times of war. Green Clay was active in the Revolutionary War[42] (a portion of his land could have been payment for his service in this conflict), and nearly four decades later, he took up arms once again as a general in order to lead troops to Fort Meigs in the War of 1812. Green was considered a hero in this particular war by coming to the aid of William H. Harrison, who was under siege at Fort Meigs in Ohio. In speaking of his valor, perhaps it was best said by Cassius: "The man who slept often alone in the wilds of Kentucky, among bears and Indians, could not be otherwise than brave."[43]

Green played a prominent role in politics, as he was a member of the House of Burgesses in Virginia, and he attended the convention that ratified the Constitution of the United States. He also served in the Kentucky legislature and the state Senate,[44] but rising to political distinction was not something that he desired. Cassius revealed, "Those who knew him best compared him favorably with Henry Clay; and, had all his powers been concentrated in one direction, they thought he would have reached equal eminence. And these were the opinions of those who were themselves eminent, and therefore very competent judges."[45]

Green was a powerhouse of wealth, and he understood the economics of saving, yet he would give generously if the mood struck him. As will soon be discussed in relation to his housing, Green had an appreciation for beauty. He enjoyed music and dancing but considered hunting and gunning a waste of his time.[46] Green was known to have a bounteous table, and yet he himself did not give in to common vices such as smoking, drinking or

excessive overeating. A common misconception among modern folk is that people did not bathe regularly in the eighteenth and nineteenth centuries. Cassius stated that Green was always impeccably dressed and "scrupulously" clean.[47] In terms of his faith, Cassius mentioned that his father was a deist.[48]

Very few personal letters are known to still exist today from those Green Clay penned. One letter (the original is archived in the Green Clay Papers at the Filson Historical Society in Louisville, Kentucky) gives a small glimpse into Green's life. The following is included with punctuation and spelling original to Green. The letter is dated January 8, 1820, and is addressed to Green's wife, Sally:

My Dear Salley,

I am now at Mr. Jarretts on the banks of the Tennessee River where I arrived the 17th. Ulto. I sent Jeff last Saturday to Smithland for letters if any were in the post office for me, & gave him two dollars to buy linnen for a bag to carry corn meal in to the woods, and pay the postage on my letters: he came home drunk at night: with four bottles of whiskey along altho I had sent for none, my money all gone, & a bill from the merchant with an account against me for a balance due for bottles & whiskey. I was so provoked I did not know what to do. He had a great big Irishman mounted up on Fox behind him, for he had broake down his horse, so that he will not be fit to ride this winter. Fox was sweating & smoaking cold as the weather was: he had waisted all the day drinking in town got loss and road hard with his man behind him, to keep from lying in the woods all night. I started Sunday for the woods with two bushels of sifted meal & a midling of pork, the 3rd time to go round the 17,000 acres on Clark's River: The surveyor failed to meet me: Monday Jeff hobbled our horses in the cane on Monday night and I have not seen nor heard of them since: I sent Jeff Tuesday after them, he returned back drunk, went to the first house where there was whiskey & no further: I started him Wednesday another course he went out of sight & then turned round through the woods to the same house (five miles off) where he got drunk the day before, & stayed out all night. I went myself the same day where I thought it was likely I might hear of the horses: but got no tidings of them: Thursday & Friday I traced up about 5 miles & a half of my lines found one corner: it began to rain; & I came back here: the nearest house to my work, I lodged at when I did not lie in the woods all night: and strange to tell the man with a wife & 5 or 6 children had not one ounce of meet of any kind nor a grain of corn or meal; nor

a drop of milk or a cow they had some turkey meet when I first arrived; they lived on my provisions while I stayed there & with comers & goers eat up my provisions: this is the 3rd time I have been but not finished the first survey: and here I am a foot. I have hired a man to go with Jeff tomorrow morning, in search of the horses: Jeff's horse was hobbled with a rope: but if there should be any whiskey in the way, I am informed there is, they will end their journey there I expect. I must start one or 2 more men out after the horses: to morrow or next day. When I left home I took bearly money enough to bear my expenses, & my expenses here are greatly more then I expected corn is 4/6 per bushel, and in some places one dollar. The man Overby sold my whiskey to, is insolvent I cant git one dollar from him: his note is for $221 the greatest plenty if I could git it, to buy me two ponies to take me home: my great coat lieing in the woods is burned in holes: the brush and greenbriars with which this country abounds has tore my sachels, legings, breeches, & great coat into strings or rather rags: here for the first time for many years past, I have dined & supped on dry bread & swamp water, I am compeled to wash down hand mill [bread] with water, I have fellen off 30 or 40 pounds I expect, with the water and the bowell complaint, my fat belly has gone down I am now as gaunt as Brutus almost.

The Indians are encamped all through this County. I am at their camp almost every day but they are like the bees that assembled at Nashvill some years ago. Quite harmless to all appearance they live wandering about seeking game and realy git more of it, and live better then half the whites: in this quarter. When Jeff has whiskey he is all noise and bustle when none he mopes about and dose but little: he is the merest Spencer that I ever saw. I had better been by myself. I am in verry good health most of my time, and all my complaints are the effects of fateague cold and hunger. You must not send me any money in bank bills by the mail for I shall be gone hence before it would arrive here. The hogs in this country are all caught or shot in the woods & killed as they run no such thing as puting up hogs to fatten with corn, the meet eats like boar meet strong & tuff: like all other wild meet nothing like our corn feed pork: bad enough as soon as you receive this letter send to Dan Dan [sic] Stevens & tell him not to make a gallery on the top of the dweling house if he has began it to stop & do no more at it. git all the money you can from Edmond Johnson at Stones Ferry send to him every week or two set all the money in writing you received & the day of the month I hire a man to take this letter to Smithland & bring me letters if any from the office. I wish you could keep the boys at school dont enter them for more than a quarter at a time.

Clermont

There is a misarable set of people in this country I have wrote everything I have to write from here I am greatly distressed in my mind & I cant Tell when I shall be relieved from it. Give my love to all the children and accept my best wishes for your wellfare and happyness in this & the next world.

Green Clay

Sunday morning Jany 9th

Tuesday morning the man I hired to go with Jeff to hunt my horses has returned & no news of them at all The men are sleeting [possibly means "sledding"] *on the Ohio at Smithland last cold weather in gangs—a man was taken sicke at Smithland last Friday & died in 10 hours:*

Tell Cassius there is one John Derro making shoes at this house, who says he and another man gathered in the Ohio lowgrounds in six days 65 bushels Of Pecon nuts The weather is as cold again as ever felt nearly Janry 11th 1820. Farewell again:

Green Clay[49]

After reading this letter, it is difficult not to feel slightly sorry for poor Green. Land surveying was hard work in those days, especially if one had an alcoholic servant with whom to contend. This letter raises many interesting questions. Was Green able to locate his horses? Did he finally finish his survey? Did Jeff get drunk again? Questions also arise as to whether Jeff was an enslaved man or just a servant hired on for the surveying job. Eight years later, when Green passed away, he bequeathed a slave named Jefferson to Cassius to be placed into trust for Green's daughter, Pauline. Could this have been the same Jeff whom Green speaks so highly of in his letter? It may never be known.

One can also gain some insight into Green's persona based on sayings he would impart to his son: "Never tell anyone your business," "Inquire of fools and children if you wish to get at the truth," "In traveling in dangerous times, never return by the same road," "Never say of any body what you would not have proclaimed in the court-house yard," "Well is the tongue called a two-edged sword," "Keep out of the hands of the doctor and the sheriff" and "My property is worth more on the farm, or in the store-room, than in the pockets of spendthrifts."[50] This last bit of advice Green certainly lived by.

As Green was one of the most powerful men in the county, with numerous enterprises and great wealth, and had his finger (or in this case hands) in all of the political pies, naturally he needed a domicile that reflected his lofty position. When Green purchased the land where the family home still remains, it was a station owned originally by Reverend John Tanner. Because the land was known as a station, it can be inferred that the tract included a log cabin of some kind.[51] If there had been a structure already present, Clay could have initially used this residence until building a better log house, or perhaps, considering the tycoon he was to become, he may have wished to save money by living in this original building until his more impressive abode was built. Once the new home was erected, the old four-room[52] log structure was left standing at the edge of the yard. It became a residence for the overseer[53] and then later was used as an office by Cassius M. Clay until it burned down in 1861.[54]

It would be a disservice to say that Green Clay "built" his home. So much of history tends to focus on the rich white man and not enough on the reality of the time. Therefore, it should be noted that although Green Clay had the funds and power to produce his domicile, more than likely he never laid a finger on any actual building materials. That would have been the job of hired individuals and, of course, his slaves. Cassius, in speaking of his father and manual labor, noted, "He never put his hand to any work on his large real-estates, because he might injure his limbs, when a subordinate would do the work as well.[55] Heaven forbid that Green hurt himself!

Construction began on the estate in 1798 and wrapped up that following year. To produce the brickwork for the home, the builders did not have to travel far, as a pit was dug on the land to provide the clay for the brickwork.[56] In addition, good Kentucky marble and gray limestone were used for the range work. This would have been thrifty on Clay's part and would have shown off some of the natural beauty that the landscape had to offer.

The bricks for the home were laid in a style called Flemish bond, in which stretchers (the long side of the brick) and headers (the short end of the brick) are alternated, with the headers being centered over the top of each of the stretchers. Originally, the house faced north, toward the Kentucky River. This is based on the fact that the front of the house is generally the most decorated, and glazed-headed Flemish bond (where the header bricks are fired to produce a darker, glassier surface) was used on the front façade, providing a fancier look to the brickwork. One account noted that the home had wooden honey locust shingles.[57]

The house was built in the Georgian style, very symmetrical, having both the front and back of the house incorporating double doors, with

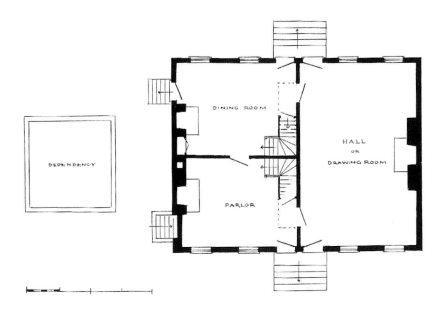

Floor plan of the first floor of the original Clermont. Floor plan and text description taken from *Antebellum Architecture of Kentucky* by Clay Lancaster, 1991. *Courtesy of University of Kentucky Press and the Warwick Foundation.*

two windows on each side of the doors and chimneys on each end of the home. Inside there was a bearing wall that would have separated both sets of double doors, dividing the first floor of the house into one large room, used as a main hall, and two smaller rooms, set up as a parlor and a dining room. The rooms on this floor were meant to impress, with twelve-foot ceilings.

The parlor and dining room each would have had a staircase leading up to the second floor, where four bedrooms, roughly equal in size, were located. Each bedroom would have had its own fireplace; however, the fireplaces on each end would have shared a central chimney. One more staircase would have traveled up to the garret, which would have run the length of the house.

Underneath the house was a full basement, with dirt flooring divided just like the first floor but reversed. There was a large single room serving as a winter kitchen, located under the parlor and dining room, with access coming from the dining room. This area would have kept food warm before taking it directly upstairs to the diners. On the opposite side under the hall would have been two other rooms. One room may have been living quarters for the cook.

The other room was more than likely a jail cell. As mentioned previously, Green Clay was a magistrate. As there was no permanent housing for those

who broke the law in Richmond at the time, Green literally brought his work home with him. It is open for contemplation whether Mrs. Clay liked the idea of having criminals housed below her great hall. Another darker and more probable use for the jail cell could have been for the housing of disobedient slaves. Documentation has never been found on this subject. Some slaveholders of the era would lock up unruly slaves. It is not known if Green did. At the time of the restoration of this building, seven sets of shackles were found within the jail cell. Because the restoration took place in the late 1960s, and the civil rights movement was in full swing, there was a hesitancy to have this area of the home highlighted on tour, and so the shackles were removed.

Oral tradition states that Green Clay bestowed the two-story brick structure with the romantic title of "Clermont." The origin of the name is not known, although some hypothesize that the name was used as a result of the house being built in a cleared space on a hill.[58] It is also open for debate whether the original home actually was named Clermont. Longstanding tradition has always maintained this, and this name has been stated as fact in many publications concerning the original home. However, no primary documentation has ever been found at this juncture to back this up. Indeed, Green never called the home Clermont in any correspondence found, including his last will and testament, simply referring to the home as "dwelling

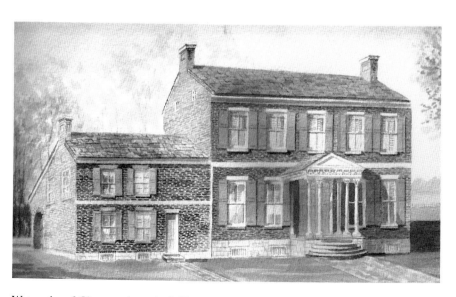

Watercolor of Clermont by artist Sallie Clay Lanham, great-great-granddaughter of General Green Clay. *Courtesy of Sallie Clay Lanham.*

house" and "mansion house."[59] Later, Cassius would refer to his father's home as "Fort Gen. Green Clay,"[60] and other family correspondence would refer to the home place simply as "the farm,"[61] so it would be interesting to discover how and when the appellation first took hold.

The woodwork inside Clermont was fairly impressive, being a mixture of pine, oak, walnut, cherry and yellow poplar. In the late 1960s, when the home was being restored, an attempt was made to refinish the woodwork; however, it was determined to be too difficult, as there were so many types of wood used it would have been impossible to make them look uniform. Therefore all the woodwork was painted over in a cream color. What may not have been known at the time of the restoration was that in Green Clay's time, as well as that of Cassius, woodwork was not always shown in its natural glory but rather painted a color or faux grained to make the lumber resemble a more expensive type of wood. In the case of Green Clay's era, paint chips have fallen off to reveal a lovely blue shade—the color the parlor may have been. Later layers of paint reveal a faux graining, which was more than likely incorporated into the parlor in Cassius's time.

Sometime shortly after 1800 (believed to be about 1810), a two-story structure was built on the west side of the home. This addition was attached to the side of the building, and the only direct access to the main house would have been through the floor of the first level into the basement area. It is believed that the winter or warming kitchen originally located in the basement of the home was moved to the bottom portion of this addition. The cook and his or her family could have moved directly over this room, as there is a fireplace upstairs. This area could also have been a storage area for preserved food, as evidenced by the enormous hooks in the ceiling of the stairwell that it can only be presumed would have held large portions of meat. A porch led off of the north side of this addition and would have also been accessible from a door leading out of the dining room of the house.

Perhaps at this point in time Green Clay decided to change the front entrance orientation of his home, from the side facing the Kentucky River on the north to the south side of the building. Large Corinthian columns would have been added to give this elevation a more impressive façade. It is interesting to note that these original columns were unearthed at a later time on the property. The reasoning behind this change in direction is not known.

In addition to the main house, there would have been many service buildings. A stone structure was built prior to Clermont's construction and was originally used as a kitchen; a stone loom house was added on to the

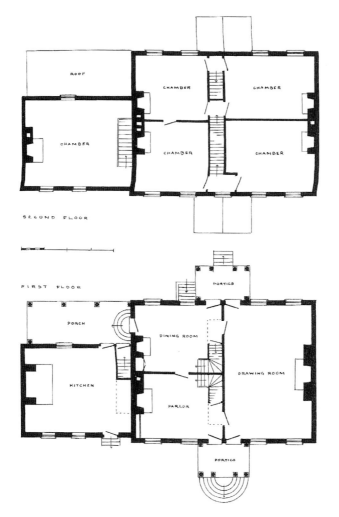

Floor plans of the second stage of Clermont. Floor plans and text description taken from *Antebellum Architecture of Kentucky* by Clay Lancaster, 1991. *Courtesy of University of Kentucky Press and the Warwick Foundation.*

kitchen a short time later.[62] There most certainly would have been barns for sheep and other livestock, as well as for crops. Cassius stated that his father was "greatly in favor of secure shelter for his stock, grain, and hay."[63] Green also raised chickens, pigeons and bees; therefore, chicken houses, pigeon houses and an apiary for bees would have been necessary. Smokehouses, icehouses, outhouses, a cider mill and another mill house and slave housing would have also been situated on the property.[64] In addition, Green Clay had a blacksmith shop, a carriage house, a harness house and at least one stone barn.[65] Green also had two artesian wells bored so that the family and slaves could have clean water to drink.[66]

Clermont

The landscape surrounding Clermont would have included numerous crop production fields, undeveloped mature treed land for future timber use and formalized gardens with flowering plants, fruits and trees directly surrounding the family home.[67] In referring to his ancestral home, a great-grandson of Green Clay, aptly named Green Clay as well, stated that Green and Sally planted trees and shrubs from "the mother state," which can be assumed was Virginia, as well as tropical plants including lemon and orange "sprouts."[68] By 1820, the Clays had cedar and pecan trees and tulip beds.[69] The finished home and lands would have been a showplace worthy of Green Clay's station and status.

Given the vast expanse of Green Clay's wealth, and the economic and political power that this man possessed within early Kentucky history, it is surprising that there is not more recognition of General Green Clay. He did get a Kentucky County named after him. There are eighteen counties in the United States named Clay County. Fifteen of those are named after Henry Clay. In the state Henry Clay resided in, the honor goes to Green, Henry's first cousin once removed,[70] who some speculate may have owned the entire county for which he was named.

No matter how wealthy and powerful, a man can't live forever, and Green Clay developed a nasty case of skin cancer on his face, possibly from all those years surveying land under the ultraviolet rays of the sun. Green knew that the end was coming and got his affairs in order before his death. Youngest son Cassius served as a nurse to his father in his final days. On the night before he died, Green called Cassius to his beside, and gesturing toward the direction of the family's cemetery, he stated, "I have just seen death come in at that door." Those were the last words he spoke.[71] The day of Green Clay's death was October 31, 1828.

In his will, Green Clay imparted all of his land in Madison County, "some 2000 acres," including the land on which the family home stood, to youngest son Cassius M. Clay. A common question asked is why did the *youngest* son get the family estate? By 1828, all of the older siblings had homes of their own. Sidney and Brutus had Escondedia and Averne, respectively, in Bourbon County. The daughters would have been settled as well in the homes of their husbands. Therefore, that left one child to inherit the house.

Among the interesting notations in the will regarding the home, Green Clay ordered that the paintings of himself and his wife remain hung in the house[72] (he would be pleased to know that they are hanging in the house even today). Clay also tried to direct his wife's life from the great beyond by stating that while she remained a widow, she could have the "west end on

half of my dwelling house & farm where I live by a line running through the house, yard."[73] This leads one to wonder if Green indeed had a line drawn through his property. Hopefully, Sally's half contained the kitchen and the outhouse.

In any event, Sally didn't want anything to do with Green's property or his will. She signed off on everything on December 1, 1828, separating herself from the legal document.[74] A few years later, she married a minister (and, incidentally, her sister's widow), Jeptha Dudley, and moved to Frankfort. This left Cassius and, by that time, his new wife a lovely home in the country with which to contend.

PART II

WHITE HALL

If a House Is Divided Against Itself

If a house is divided against itself, that house cannot stand.
—Mark 3:25, World English Bible

In some ways, General Green Clay and his son, Major General Cassius Marcellus Clay, could not have been more different. Green Clay was a wealthy tycoon—nearly everything he touched turned to gold. Cassius M. Clay lived his life trying to stay ahead of his debts. The father was a massive slaveholder, believing that slavery was a necessary means of doing business. The son felt that business would be better if slaves were emancipated. One thing they did have in common was a taste for impressive houses. Cassius, with his wife, Mary Jane, would eventually add on to the Clay family home, transforming the palatial country estate into a towering, eye-popping abode. However, before we get to the building, let's look a little at the man (and woman) behind the mansion.

Cassius M. Clay[75] led a charmed life. He grew up in an impressive home with a bountiful table and enslaved individuals to cater to whatever needs he and his family had. Cassius was well educated and was given the foundation at home to provide him with the financial security, social connections and extreme self-confidence to rise up in the world.

Clay's rise to fame began with his educational studies. Perhaps because he had had so little schooling,[76] Green was very generous with providing the means for ample education for his own children. Cassius stated that he attended a number of local area schools, as well as Danville College and Jesuit College,[77] before going on to attend Transylvania University in Lexington, Kentucky, and then later Yale University in Connecticut.[78]

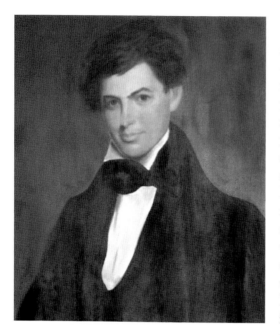

Portrait of Cassius M. Clay. This is a reproduction, which resides in the drawing room of White Hall. The original portrait was painted by Oliver Frazer and hangs in the Madison County Courthouse. *Courtesy of Kentucky Department of Parks and Liz Thomas Photography.*

While at Transy, Cassius resided in the main building on campus. On a Saturday night in May 1829, Clay was peacefully snoozing in his room while his male slave polished some boots on the stairs. The slave had placed a candle on the steps so that he could view his work but fell asleep without blowing out the flame, which soon tipped over and set fire to the stairway. The building went up in flames rather quickly. Fortunately, no one perished in the fire. Unfortunately, the building was destroyed. Such was the embarrassment of Clay over this incident that he never admitted any connection to this event until he was in his late eighties.[79] It is believed that after the fire took place, having no dorm to live in, Cassius went to visit with the Todd family of Lexington. Cassius considered Robert S. Todd, the patriarch of the family, his "old and faithful friend."[80] One of the daughters, Elizabeth, would be a bridesmaid at his future wedding, and another daughter, Mary, would one day become the wife of a man Cassius and a great portion of the rest of the nation would respect: Abraham Lincoln.

Cassius also studied at Yale University but managed not to burn anything down. Cassius's attendance at Yale would affect him in a major way and would influence Clay to devote his life to the antislavery pro-emancipation cause. What were the factors that played a part in Cassius becoming an emancipationist? The young Clay already had misgivings about the "peculiar institution," for Cassius stated that he entered Yale with "my soul full of hatred to slavery"[81] At a grass-roots level, it could be hypothesized that Cassius's mother may have played a role in forming his opposition. Clay stated in his *Memoirs* that "at all events, the mother, being both parent and

teacher, mostly forms the character."[82] One could also imagine that Cassius's older brother, Sydney Payne Clay, had a great deal of influence, as he was also an emancipationist before his untimely death. There also were incidents that occurred that Cassius would have viewed growing up in a slaveholding family. Cassius stated that "my father being the largest slave-owner in the State, I early began to study the system, or, rather, began to feel its wrongs."[83]

One incident that had a lasting impact on Cassius involved a family slave by the name of Mary. As a young boy, Cassius had been interested in gardening, and Mary assisted him in plotting out a garden. According to Cassius, a few years later Mary was sent to a separate plantation to cook for the whites, the "hands" and the overseer, named John Payne, and his family. Cassius stated that Payne verbally abused Mary, and when she objected, she angered not only Payne but also his whole family. The family sent her upstairs in their cabin to shell seed corn for planting. Mary was suspicious that something was up and hid a butcher knife in her clothes before she went upstairs. Meanwhile, the Payne family plotted a vendetta below. Eventually, the Paynes came upstairs and attempted to attack her, but Mary turned on them and fatally stabbed John Payne. At this point, she was able to make her escape and ran back to Clermont.[84]

In June 1820, Mary went on trial for the murder of John Payne. The trial took over a year and half to complete. At first, the court proceedings took place in Madison County, but after it was determined that Mary might not receive a fair hearing there, the trial was moved to Jessamine County. At one point, it was debatable whether Mary would live through the trial, as the horrid conditions of her jail cell compromised her health. A doctor was called in to examine her and provide an affidavit—for Mary to survive; she had to be removed from the unheated jail that was so open to the elements. It took Mary several months to recover from her illness. Throughout the trial, numerous witnesses were called for the Commonwealth, while many other witnesses spoke on behalf of Mary, including Sally Lewis Clay. This fact might lead one to suppose that the Clays believed their slave when she said that she had killed in self-defense. The trial finally came to a close in October 1821.[85]

Cassius M. Clay seems a little bit hazy on the actual proceedings of Mary's trail; he stated in his *Memoirs* that Mary was acquitted of the murder, "held guiltless by a jury of, not her 'peers,' but her oppressors!"[86] According to the official court documents, Mary was actually found guilty of murder and sentenced to execution on December 1, 1821. The pardon by Governor John Adair on November 13, 1821, was what saved her life.[87]

Although she was pardoned by the governor of Kentucky, Green Clay's will instructed that she and a number of other slaves be "sent beyond the limits of this state" and sold "for the best price that can be had with a warranty that they non neither of them shall ever return to reside within this state thereafter."[88]

At the time of Green Clay's death, Mary was still fairly young. It is estimated that she would have been in her late twenties to early thirties and therefore could have had several more years in which she would have been productive in her service to her masters. Why then, was Mary still sold? Had Green Clay worked out a compromise with the governor? Was the stigma attached to Mary too great? Were there other factors that could have resulted in Mary being sold?

Perhaps its possible that Mary had a closer connection to Green than was openly known. In describing Mary, Cassius stated that "[s]he was a fine specimen of a mixed breed, rather light colored, showing the blood in her cheeks, with hair wavy, as in the case with mixed whites and blacks. Her features were finely cut, quite Caucasian."[89] In reference to his father and the possibility of a child out of wedlock, Cassius stated, "In the discipline of women, my father knew, as every sensible man knows, the strength of the sexual passions. Nature ever tends to the preservation of the races of animals. Opportunity, notwithstanding all the sentimentalism about innate chastity, is the cause of most of the lapses from virtue."[90] The possibility that Mary was an illegitimate child of Green Clay's is not entirely unlikely.

Whether Cassius M. Clay remembered the exact proceedings of Mary's trial is not as relevant as the impact his father's will made on Mary's life and, as a result, on his own life. Clay's older brother, Sydney P. Clay, was executor of Green Clay's estate. Although an emancipationist himself, Sydney was required to execute his father's last orders. Cassius recalled his final time seeing Mary: "Never shall I forget—and through all these years it rests upon the memory as the stamp upon a bright coin—the scene, when Mary was tied by the wrists and sent from home and friends, and the loved features of her native land—into Southern banishment forever...Never shall I forget those two faces—of my brother and Mary—the oppressor and the oppressed, rigid with equal agony!"[91]

Certainly, the idea of antislavery had to have been introduced to a young Cassius before he attended any higher educational institutions. However, Clay credited the voice of the abolitionist William Lloyd Garrison as being the straw that broke the camel's back.[92]

It wasn't just persuasive and influential people in his life who would have caused Cassius to go in this antislavery direction. Nor was it simply

a morality issue with Clay. In his travels in the North, as well as his time at Yale, Cassius saw how business was done. The economy did just as well if not better in the New England states without the institution of slavery. Cassius believed that the South's economy could do the same. In fact, he felt that the southern states could not continue with slavery and survive successfully in the future. Furthermore, Clay believed that slavery took away jobs from the working-class white population.[93]

Many people in the past and even today have called Cassius M. Clay an abolitionist. Clay personally objected to being called this, stating that it was "a name full of unknown and strange terrors and crimes to the mass of our people."[94] Cassius was undeniably an emancipationist. The two terms diverge in that an abolitionist believed that slavery should end all at once, by legal or illegal means (hence the Underground Railroad and other illegal practices of assisting slaves to freedom). An emancipationist wanted a gradual end of slavery. This measured autonomy would allow the slave owner to prepare economically for the loss of his or her property and also give the enslaved time to mentally adjust—emotionally and in terms of literacy and job preparation—before having the concept of independence thrust upon them.

Cassius felt that since the law sanctioned slavery, the law should then eliminate it, stating that "I consider law, and its inviolate observance, in all cases whatever, as the only safeguards of my own liberty and the liberty of others."[95] Clay practiced what he preached in regard to dealing with his own slaves. Although Cassius freed his own slaves, there were a number he could not liberate legally because they had been put into trust for Cassius's children through his father's will.[96] Technically, those particular slaves belonged to Cassius's offspring, and he did not have the right to legally emancipate them, and so these people were enslaved until freed by the Civil War. In a letter to the abolitionist Reverend John G. Fee in 1855, Cassius defended his actions:

> *I feel it my duty to keep my children's slaves together and control them, rather than by disavowing any authority over them to allow the sheriff to hire them singly to the highest bidder. I have been in the habit of allowing them such privileges and wages as I think suitable to their condition as slaves, and the responsibility upon me for their support. I consider that I have done my duty when I have done all in my power to bring about legal and peaceable emancipation. Besides, I do not set myself up as perfect: far from it. A balance sheet of good against evil is all I aspire to.*[97]

Cassius stated in his *Memoirs*, "I never sold a slave of mine in my life. The slaves sold…were trust-slaves—the title being in me only as trustee. I sold them for crime, as was directed in such case by my father's will; and the proceeds were re-invested in lands, in Lexington, for the benefit of those for whom the '*cestui qui* trust' was created."[98] In addition, Clay stated, "I never received a dollar from a slave of mine in my life. On the contrary, I liberated all the slaves I inherited from my father and thirteen others whom I bought to bring families together, or liberated at once…The buying and liberating of these slaves, half of whom never entered my service, cost me about ten thousand dollars."[99] It should be noted that although he claimed to have never purchased slaves on his own behalf (aside from those in which he was trustee), Cassius was not opposed to *borrowing* slaves from his brother Brutus when he needed them.[100] Being a large slaveholder, Brutus followed more along the lines of his father Green's philosophies when it came to the issue of slavery and did not subscribe to his younger brother's ideals.

Cassius endured criticism and conflict not only from his peers of the white populations but also from his own slaves as well. At one point, Clay went to court over his slave, Emily, whom he believed to have poisoned him and one of his sons.[101] Another time, Cassius went to court for shooting a former slave, Perry White, in self-defense. This altercation, nearly thirty years later, also stemmed from an alleged poisoning of a son of Clay's.[102]

It may be difficult for those today to fully understand the extreme division and personal moral conflict that contemporaries felt at the time regarding slavery. When speaking a generation after slavery was abolished, Clay himself attempted to convey what it was like: "The present generation can know nothing of the terror which the slave-power inspired; but it can be faintly conceived, when a professed minister of the Christian religion in South Carolina said that it were better for him, rather than denounce slavery, 'to murder his own mother, and lose his soul in hell!'"[103] Cassius himself was Christian in faith, but he did have issues with churches and religions that touted slavery as a "divine institution." In reference to those who believed as such, Clay stated, "I had no fellowship with men with such a creed; and I preferred, if God was on that side, to stand with the Devil rather; for he was silent, at least. So, if I said and wrote hard things against the Scriptures, and especially the preachers, it was because they were the false prophets which it was necessary to destroy with slavery."[104]

It would be safe to say that educating the masses on the evils of slavery was a great love of Cassius's. Another great love would be his first wife, Mary Jane Warfield. In every great epic, there is a love story. Many times,

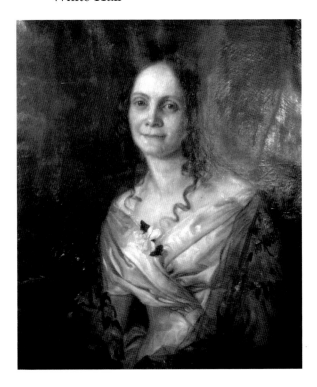

Portrait of Mary Jane Warfield Clay by artist George Peter Alexander Healy. *Courtesy of Catherine Clay.*

people will meet their future mate while at college, and such was the case with Cassius M. Clay. While he attended Transylvania, the second daughter of prominent Lexington physician and horse breeder[105] Elisha Warfield caught the young man's eye. Mary Jane Warfield had long, luxuriant auburn hair with large light grayish-blue eyes.[106] She was graceful, had a talent for conversation and possessed a beautiful singing voice, and Cassius was so taken by her that before he left for Yale he gave her a copy of Washington Irving's *Sketch-Book* with some sweet words inscribed therein.[107] Upon returning to the Bluegrass Region, he visited her father's home frequently enough to have Miss Mary Jane notice him right back.

It probably wouldn't have been hard to notice Cassius, as he was somewhat of a looker himself, standing about six feet tall,[108] weighing in at about 183 pounds[109] and having fair skin, with dark hair and dark gray eyes (these genetics he attributed to his mother's side of the family).[110] The Cash man was also probably in tiptop shape physically as he enjoyed sports and was rather athletic.[111] Sparks had to have flown across the parlor of the Warfield home, but it wasn't until a hickory nut hunting party that they truly discussed their feelings for each other.

Cassius situated himself under the trees and made himself useful by hulling the nuts while others, including Mary Jane, went about gathering the bounty and dropping off their collections in a pile beside Clay. At one point, when other members of the party had wandered off, Mary Jane approached Cassius with her handkerchief full of the *carya* fruit, which she emptied onto the pile. When Cassius asked her to "Come and help me," Mary Jane replied, "I have no seat." Quick-witted Clay put his legs together and quipped, "You may sit down here, if you will be mine." It's doubtful that hickory nuts were the only things on Cassius's mind when Mary Jane sat down on his lap, brushed his face with her hair and murmured, "I am yours" before flitting off to be with her friends. Cassius was left to wonder if Mary Jane's technique was "simplicity, or the highest art?"[112]

It was like a scene from a movie. Some individuals at the time might have married for money, power or title, but it appears that Cassius and Mary Jane married for love, although there would be a few obstacles to overcome before they actually made it to the altar. One made itself known right after the nut hunting party ended. Cassius's cousin, whom he refers to as Mrs. Allen, noticed the attraction, took the young man to the side and stated, "Cousin Cash, I see that you are much taken with Mary Jane. Don't you marry her; don't you marry a Warfield!" Mrs. Allen went on to list a number of eligible young ladies in the area whom Cassius could turn his attentions to, but to no avail—Clay was smitten.[113]

Another impediment to the star-crossed lovers was Mary Jane's own mother, Maria Barr Warfield. In the grand tradition of intrusive mothers-in-law, she seemed to have hated Cassius's guts. The trouble may have started when Cassius asked Elisha Warfield for Mary Jane's hand in marriage rather than his future mother-in-law. Perhaps Maria felt that Mary Jane should marry a doctor like her father, or maybe it was in retaliation for the proposal slip up that caused Maria to give Cassius a letter written by a former beau of her daughter's. Dr. John Declarey had said some unkind things about Clay's character in the letter, and Cassius felt that he had to defend his honor.

What does a gentleman do in Clay's time when he is insulted in a letter? Why, he goes and beats up the person who wrote the missive! Clay, with his "best man" James S. Rollins, traveled to Louisville, where the offending physician resided. While Rollins held bystanders back, Clay beat the tar out of Declarey in the middle of the street in front of his own hotel. Of course, Declarey responded with a challenge to a duel, which Cassius was only too happy to accept. The two men tried several times to get together to fight without large crowds following them but were

unsuccessful, so Clay and Rollins headed back to Lexington, with Clay almost missing his own wedding. Thus under such drama were Cassius and Mary Jane joined in matrimony.[114]

Word would eventually reach Cassius that Declarey had boasted if he ever saw Clay again he would "cowhide" him (a serious offense at the time, reserved for such individuals as slaves). This caused Clay to again head back up to Louisville, but this time to do so alone. He again went back to Declarey's hotel and waited for him in the dining room of the establishment. Clay was there leaning against a pillar when Declarey finally returned home. The doctor did not challenge Cassius but did turn a few shades paler and hurried away. Cassius hung out in Louisville for a few days after that hoping to drum up a fight, but Declarey never contacted him, so the newlywed returned home. Clay discovered later that the reason Declarey never communicated with him was because he was dead. The doctor had committed suicide by "cutting his arteries." Perhaps the fear of actually going through with another physical confrontation with Cassius was too much to bear, or maybe dying was less of an embarrassment than getting beat up. In any event, Cassius never blamed himself for Declarey's death, but rather Maria Barr Warfield.[115] Pass that buck right along.

Although the marriage began with such a rocky start, Mary Jane and Cassius did enjoy (more or less) forty-five years of wedded bliss together. The marriage produced ten children: Elisha Warfield Clay (May 18, 1835–June 21, 1851), Green Clay (December 30, 1837–January 23, 1883), Mary Barr Clay Herrick (October 13, 1839–1924), Sarah Lewis Clay Bennett (November 18, 1841–February 28, 1935), Cassius Marcellus Clay Jr. (1843–1843), Cassius Marcellus Clay Jr. (1845–April 15, 1857), Brutus Junius Clay (February 20, 1847–June 1, 1932), Laura Clay (February 9, 1849–June 29, 1941), Flora Clay (1851–1851) and Anne Warfield Clay Crenshaw (March 20, 1859–1945).

Cassius and Mary Jane began their married life together with a seven-room brick home to make their own. It was soon decided that Clermont was a little too far out in the country. Lexington seemed a better fit for the young couple. Mary Jane liked being near her family, and Cassius liked being near the politics. The Morton House, located on the corner of Limestone and Fifth Streets in Lexington, looked like an ideal place to resettle. Cassius called the home "the most elegant in the city,"[116] and he purchased it in the late 1830s for $18,000.[117] The home itself was unusual when compared to other early Kentucky houses in that it was a brick home with stucco covering it.

While he was residing at the Morton House, Cassius began to set his sights on a political career. He studied law at Transylvania, and even

though he was not interested in working in that profession (and actually never took out a license to practice),[118] Clay could have been very successful had he chosen to go that route. A man accused of murder once asked Clay to represent him in court. The man allegedly killed his neighbor after the neighbor had given him a threatening look. Terrified, the accused claimed that he killed the man in self-defense. Upon hearing of the circumstances, Cassius's "fighting blood was roused," and he took the case. The prosecution brought forth the evidence, and it seemed cut and dried: the accused murdered a man in cold blood. Why should Clay even bother to present his side? Undaunted, Cassius quietly made his case and, according to one observer, "laid all the proof before them in a masterful way." Near the conclusion of his arguments, Clay suddenly turned and gave the jury a chilling glare. The jury, alarmed by this sudden twist, recoiled in fright. Clay then asked, "Gentlemen of the jury, if a man should look at you like this, what would you do?" In response, the jury after a short deliberation decided on a not guilty verdict for the accused.[119] Apparently, looks *can* kill.

The jury's response to Clay's glower is not surprising, since only an insane person would have wanted Cassius M. Clay's temper directed at him or her. Over his lifetime, Clay became well known for not backing down from a fight. This characteristic became very public when Cassius began working on his career in earnest. Politics, antislavery speeches and fighting all seemed to go hand in hand in the 1840s for Cassius. While Clay did not reach the top in terms of political eminence, he was exceedingly talented in the other two departments.

When writing his *Memoirs* in his seventies and glancing back at his life and his dubious standing,[120] Clay stated, "My reputation as a 'fighting man,' as the phrase goes, I have never gloried in. On the contrary, it has always been a source of annoyance to me; overshadowing that to which I most aspired—a high and self-sacrificing moral courage—where the mortal was to be sacrificed to the immortal. And, after a calm review of my whole life, I can truly say that I have never acted on the offensive; but have confined myself by will and act to the defensive."[121] Clay was always certain to act if he felt like his views or his (or his wife's) honor were put into question.

Dirty politics is not a modern invention. In 1840, a rival of Clay's for a seat in the Fayette County General Assembly, Robert Wickliffe Jr., brought Mary Jane Clay's name up in an uncomplimentary way during a speech. Naturally, Cassius challenged this mudslinger to a duel. Upon hearing word of this fight, Cassius's distressed mother, Sally, took pen in hand and wrote to him on August 2, 1840:

White Hall

Cassius, My Dearly Blv'd Son.

You don't know the anxiety I have felt since I heard you became a candidate last night. I heard there is a report in town that you and Rob. Wickliffe were expected to fight, altho I can't believe it; still I feel unhappy knowing your disposition & sense of honour. How can a rational man think it honourable to disobey his maker's law which says thou shalt not kill? How does it look for men to go out with their physician with them to try to take each other's life and one kills the other? The survivor lives a miserable life here and without the sovereign mercy of God, dies and is miserable to all eternity! Oh! my son, think of the shortness of life and the vanity of all earthly fame. Surely you will not take it amiss for your Mother to exhort you to be upon gard [sic], you are very dear to my heart; there is no earthly tie stronger than the love an affectionate mother feels for her children; don't be anxious, and if you are not elected show your philosophy that is more noble than vengeance, which the Almighty says belongs to himself. I hope the Lord will protect you: farewell. My love to M. Jane and the children.[122]

Clay eventually ended up dueling Robert Wickliffe. The two were spaced ten paces from each other and fired one shot with pistols, each one missing the other. (Apparently, the Lord did protect, as Clay's mother had hoped.) Although Cassius wanted to try again, the seconds convinced him to let the matter rest.[123]

Even though Clay dueled with Wickliffe, Sally's words did have an effect on him. At the bottom of her original letter, housed in the J.T. Dorris Collection of Special Collections and Archives at Eastern Kentucky University, Cassius penciled the words, "Note: This letter so full of good sense and coming from one whom I loved above all the world determined me never again to fight a duel: and I never have. C. 1884."[124] Cassius came to think of dueling as a waste of his time,[125] and while a duel might have resulted in minor or no bodily harm, an actual skirmish with Cassius generally brought about serious maiming or death on the adversary's part.

The battle did continue on between Cassius and Robert Wickliffe Jr. This time, instead of doing the fighting himself, Wickliffe chose to hire an assassin. The hit man was named Samuel Brown. Brown decided that his rendezvous with Cassius was to be on an August day in 1843. The location was a rally at Russell's Cave in Fayette County. Perhaps the day was overcast, for Brown chose to make himself known first by calling Cassius a liar in the middle of Clay's speech, then following that claim up with a hard rap against the offending man

with his umbrella. Cassius was in the process of withdrawing his Bowie knife when Brown produced a more effective weapon—a deadly pistol—and fired at point-blank range at Cassius's chest. In retaliation, Cassius took his knife and proceeded to carve Sam up like a Thanksgiving turkey. By the time he was done, Brown had lost an eye, nearly lost an ear, had his nose slit and his skull cleaved to the brain. A number of men threw nearby chairs and hickory sticks at Cassius, while others grabbed him to get him off Brown, though they knew that Clay would eventually get loose. To save Brown's life, they threw him (Brown, not Clay) over a nearby stone fence.[126]

How did a man who had been shot at close range still defend himself to the point that multiple people were called to restrain him from his attacker? Brown shot his gun just as Cassius was taking his knife out of his waistcoat. Upon later examination, it was revealed that the bullet had hit the knife's scabbard (which was lined with silver) and had become lodged there instead of in Clay. It would seem that Providence once again intervened for Cassius. Clay thought so himself, as he mentioned, more than thirty years later, "And when I look back to my many escapes from death, I am at times impressed with the idea of the special interference of God in the affairs of men; whilst my cooler reason places human events in that equally certain arrangement of the great moral and physical laws, by which Deity may be said to be ever directing the affairs of men."[127] It seems that Cassius felt God was certainly on his side in this particular fight.

In an odd and certainly unfair twist of events, it was not Samuel Brown, the paid hit man who threw the first punch and shot with intent to kill, who was put on trial for mayhem, but rather the victim of the attack, Cassius M. Clay. Cassius's famous second cousin, Henry Clay, and his brother-in-law, John Speed Smith, represented him in court. Justice was on Clay's side, as he was found not guilty.[128] Although Clay extended the hand of friendship to his adversary, Brown never accepted the offer and was later killed in a steamboat accident. Cassius stated in his seventies that of all the men he fought in his lifetime, Brown had been the bravest.[129]

With his views concerning slavery, Cassius M. Clay was not the most liked man around. To add more flames to the fire, in 1845 Clay decided to start his own newspaper. Cassius had gotten into the habit of writing to the local newspapers on the subject of slavery, as well as his opposition to it. The newspapers were less than amused—Lexington being a major slaveholding town at the time and the surrounding areas also being very much proslavery—and stopped publishing the letters. This did not deter young Cassius one bit.

To ensure his freedom of speech, he established the *True American*, an antislavery newspaper that was published in Lexington and was so controversial that people were up in arms before the ink was wet on the newsprint. Clay received numerous threatening letters, one supposedly written in blood. It looked very much like a mob might advance on Clay's office and take it down by force.[130] His answer to this was to reinforce the exterior doors with sheet iron (to keep the doors from being burned) and outfit the office with an arsenal fit for war (including a number of guns, Mexican lances, two brass cannons and a keg of explosive powder, complete with match). The cannons were placed breast high and were stuffed with nails facing the direction Clay assumed the mob would be arriving. His plan, it is supposed, was that he (or some of his allies) would shoot the cannons at the enemy, light the keg of powder and escape out of trapdoor in the roof of the building.[131] Clay believed in being prepared.

As it turned out, a mob did show up. Calling themselves the Committee of Sixty and for the most part composed, surprisingly, of Clay's friends, the

Photograph of the building that housed the *True American* printing press, located at No. 6 North Mill Street, Lexington, Kentucky. This building was razed at the turn of the twentieth century. *Courtesy of Kentucky Department of Parks.*

group was slightly more civilized than what Cassius had been expecting. This group secured a bogus court order from a sympathetic judge to stop the production of the *True American*. At the time, Clay was in bed sick with typhoid fever. He was forced to surrender the keys to his office and allow the group to go in and dismantle his press, which was shipped off to Cincinnati, Ohio. The newspaper continued production in that city, with Cassius editing it in Lexington.[132] The newspaper was later purchased by the *Louisville Examiner*.[133] Cassius ended up having the last laugh; he sued the secretary of the Committee of Sixty, James B. Clay (Cassius's own cousin and son to Henry Clay—how's that for adding insult to injury) for infringing on his freedom of speech rights and was awarded $2,500 for his pain.[134] With friends like these, who needs enemies?

Clay's approval rating among his peers was at an all-time low. Fortunately for him, the Mexican-American War was just beginning. Although Clay did not agree with what the war stood for (he felt, like many antislavery people at the time, that the war was an excuse to add more slave territory to the South), he suspected that he could potentially go to war and come back a hero. That is exactly what happened. In a capricious expression of their sentiments, the very same people who would have run Cassius out of town before he went off to the Mexican-American War had a parade for the man and presented him with a sword for his bravery in that war upon his return.[135]

So what did Clay do that was so heroic? He headed out in the latter part of 1846 with the First Kentucky Volunteers as a captain. Upon arriving in Mexico, he and his regiment were very quickly captured by the Mexican troops. The Americans discovered, much to their dismay, that not posting pickets results in the enemy successfully being able to surround and capture a target without a single shot being fired. When the Mexicans threatened to kill the Kentuckians after one of the captains escaped, Cassius reportedly stepped forward and stated, "Kill the officers; spare the soldiers." A Mexican general came forward and, cocking his gun against Cassius's chest, prepared to take him at his word. Undaunted, Cassius went on to say, "Kill me—kill the officers; but spare the men—they are innocent!"[136]

Apparently, the Mexican company was so impressed that it did not kill anyone. The company did, however, retain Cassius and his fellow soldiers as prisoners. On the march to Mexico, and also once under house arrest, Cassius did everything in his power to make sure that his soldiers and the others who were captured were as comfortable as he could make them. He sold his own belongings to do this, and Clay "expressed his regret that he was

unable to do more." One of the soldiers incarcerated with him stated that Cassius M. Clay was truly "the soldier's friend."[137]

Regardless of the fact that he was hailed as a hero by his fellow Fayette Countians, by the late 1840s Clay's political career in that county had reached an end, and so Cassius and Mary Jane sold the Morton House in 1850, packed up the kiddies (by this time all but two of their ten children had been born) and traveled back to Madison County (where the political grass was a bit greener) and the family homestead of Clermont.

In 1849, Cassius began assisting antislavery candidates in their bid in the Kentucky Constitutional Convention. This convention would decide the fate of the future of slavery in Kentucky. Madison County allowed two delegates. One of the nominees, a local lawyer named Squire Turner, did not like Clay's tactics. To be fair, when one goes to speak to the public, it is rather annoying to have another person there who rebuts everything one says. Cassius continued this irritating behavior until a speech at Foxtown. Normally, Clay went everywhere armed to the teeth, but this particular rally was near his home, and so he arrived with "only" a Bowie knife.

Squire got up to speak in a positive way regarding the slavery issue, with a few biting negative remarks aimed at Clay. To further infuriate Cassius, he went way over his time limit. Clay once again stood up right after Turner ended his speech to refute what Turner said and to complain that he did not have adequate time to rebut Turner's speech. Turner's son, Cyrus, took specific offense to Clay's words, and when Clay came down from the table he had been standing on while speaking, Cyrus hit him. Clay drew his knife but was held off by about twenty men (interesting that it took that many), and his knife was taken from him. Clay was beaten with sticks and stabbed in the side, but he still was able to grab his knife back (he had partly grabbed it by the blade and cut two of his fingers to the bone in the process) and make his way to Cyrus, whom he stabbed in the abdomen. As seemed to be the case with Cassius, he once again made an apology to the man he had injured, and this time the apology was accepted. Cyrus Turner died soon after, and Clay took some time to heal from his wounds.[138]

Although there are numerous accounts regarding Cassius M. Clay's eloquent speeches, his fiery temper and expertise in combat, little has ever been mentioned of Clay's personal qualities, and what the man was like when he wasn't behind a podium orating. In the examination of family letters, Clay revealed soft spots when he discussed his children to his wife, particularly the youngest, Annie.[139] However, the only third-person narrative that the authors have ever found giving an insight into the family man that

Clay was is a biography of Cassius written by his eldest daughter, Mary Barr Clay. Although Mary, like everyone else, does focus on the political realm that Cassius was involved with, she also gives some insight into the private man:

Father was very fond of flowers and music, and spent much money on us children for our musical education—uselessly, for none of us had much talent in that line. He was one of the most forgiving men, and generous to a fault. Living as he did surrounded by his enemies in our neighbors, some of whom sought his life. They would ask favors of him, and he never failed to grant them if it was possible for him to do so. We never knew from him who they were. He allowed us to go to their homes, and they came to ours, and never a word did he say against them. What we knew of them was told us by others. He loved fishing, and often went to the river back of our farm, and other streams, to enjoy the sport. On one occasion the men were having a barbecue on the river, and were out swimming, when Mr. David Willis became cramped, and while all the others were paralyzed at the danger of going near him, they called for "Clay" who was some distance off. He plunged in the water and seized him by the hair as he went under the third time, and brought him safely to shore, and saved his life.

He required strict obedience from us, but I remember only three times of his punishing us himself. Mother did that. A word from him was enough, as well as from her, generally.

My earliest recollections of my father was of his carrying the sick babies in his strong arms, and with a crooning song lulling them to sleep. He was the tenderest of nurses.

When we lived in Lexington, often when he came home from his printing office, he would take off his coat and get down on all fours and play horse, while we would climb upon his back, when the horse would suddenly rise up, or kick up and scatter children right and left. On one occasion I remember the servantman came ushering a gentleman, Mr. Charles Sumner, into the library, who no doubt was much amused and surprised at the performance.

We had a large cherry tree at the front door, and when cherries were ripe he would climb up and begin to eat them without throwing us any. We would call up to him to throw us some. He would say, "Dad's sick." We would begin to pelt him with sticks and grass until he was tired out, when he would throw us all we could eat. When at home from one of his speaking tours, when he wanted to take a nap, he often preferred to do so

in the room where we were sitting, where our voices lulled him to sleep.
He rarely used a pillow, but would lie with his arm under his head; he
could sleep anywhere, no matter how hard or uncomfortable his position
seemed to others.

His library adjoined our sitting room, and mother endeavored to keep it
quiet for him to rest. He enjoyed reading Don Quixote, and would lie by
the hour screaming with laughter over it. He was full of playing pranks
on us children. He was particularly fond of the youngest ones, as he said:
"The older one had too much will." We would say in reply "like our
Dad." He loved to be with our young visitors, and always made himself
agreeable to them.[140]

Cassius may have been an accomplished fighter, but through the eyes of his daughter, he was also a great dad.

There was a break from violent episodes involving Cassius for a time. He was still very active in the antislavery cause. One could say that a college was built because of his beliefs. Cassius had heard of the abolitionist Reverend John Gregg Fee and the persecution that Fee had suffered for his beliefs regarding slavery. Clay invited the minister to Madison County and gave him a tract of land for a house, as well as $200 in order to build it. In addition, Clay also gave Fee land on which to build a church and a school. The school would become Berea College, an institution where the white and black populations, be they male or female, could acquire an equal education. Founded in 1855, the organization became the first interracial and coeducational college in the South[141] and is still a thriving college today that is one of a handful of educational institutions that offer free tuition to its students. Although Clay credited Fee with being responsible for the success of the institution,[142] some acknowledgment should go to Cassius for providing the means by which the college got its start.[143]

Cassius continued on with his political rounds, speaking out against slavery at every meeting he could attend. Many times, doors were closed to him, so Clay took to speaking outside. Such was the case in 1856 in Springfield, Illinois. Cassius spoke for a few hours on universal freedom while Abraham Lincoln sat under the trees, whittling wood and listening.[144] That was the first time that Cassius had met Lincoln, although he was a good friend of Lincoln's wife, Mary Todd Lincoln, and her family. Of that first encounter, Clay always felt that he might have had some impact on Lincoln's views regarding slavery, as he stated, "I sowed there also seed which in due time bore fruit."[145] Four years later, the two men happened to meet each other

once again on a train. Cassius, never shy about his beliefs and also not one for brevity when it came to discussing his view on a subject, had a lengthy one-way discussion with Lincoln on the issue of slavery. After silently listening to Clay, Lincoln made the plain but pithy remark, "Yes, I always thought, Mr. Clay, that the man who made the corn should eat the corn."[146]

Both men were up for the presidential nomination at the Republican Convention in 1860. (An interesting side note is that Cassius M. Clay was a founder of the Republican Party.) Cassius was also up for a vice presidential nomination; however, Lincoln took the presidential vote for the party, and Hannibal Hamlin was the choice for vice president.[147] Although not the popular choice, Cassius still did his part campaigning for Lincoln, and he was sure that once Lincoln was made president, a high political office would be his. Lincoln was victorious, but the hoped-for appointment was not immediately forthcoming. Cassius finally went to Lincoln and reminded him of all of the hard work he had done on the new president's part. Although Clay was offered a ministership to Spain, he declined that post and eventually accepted the position of minister to Russia.[148]

Illustration of the candidates for the Republican presidential nomination at Chicago, taken from *Harper's Weekly*, Saturday, May 12, 1860. Notice Cassius M. Clay in the bottom-right corner. *Courtesy of Kentucky Department of Parks.*

White Hall

Although she stood by her husband, Mary Jane was not as excited over the prospect of a potential move. In an 1861 letter dated March 12, Mary Jane wrote to her sister, Katy, about the love she had for her home and her fears concerning her husband's political appointments:

> *I have done all the gardening & other work in the grounds that can profitably be done yet awhile & am quietly writing to see if Mr. Lincoln means to appoint Mr. Clay to any mission, which he will accept. If he does, it will break us up here, I suppose, as all will want to go with him & the girls are heartily tired of country life. The place grows more beautiful & more dear to me continually & if I consulted my own pleasure I would remain just here. This a bright morning & the grass & evergreens look so beautifully. My fit flowers are as luxuriant as possible the birds are singing gaily, all nature is smiling! Ah! My own loved home, how my heart throbs at the thought of giving you up, well, we all <u>must</u> submit to circumstances, so I will not repine!*[149]

Submit to circumstances she did, for in the spring of 1861 Cassius, Mary Jane and five of their children were packed up ready to leave for Russia when there was a fear that the Confederate forces would overtake the White House. Cassius, with other men, formed a group of volunteers to protect the White House and Capitol. Called the "Clay Battalion," the men stood guard

Photograph of the Clay Battalion, circa 1861. Cassius M. Clay is said to be the man in the foreground wearing light-colored trousers. *Courtesy of Kentucky Department of Parks.*

until other reinforcements came in. Cassius was offered a military post at this point but felt that he could best serve his country (and himself) by traveling over to Russia.[150] He did, however, accept the title of major general.

Unfortunately, Clay may have been a bit of an embarrassment to Lincoln and his cabinet. Cassius was outspoken as always, and on his stops to England and France on the way to Russia, he berated those two countries for being sympathetic with the United States South. Fortunately, Russia tended to think more along the lines of Clay, and he found the imperial Russian court very agreeable. Russia at the time was just coming out of an ancient feudal system. The czar at the time, Alexander I, had freed the serfs in 1861, right before Clay arrived in the country. Clay was very complimentary and worked very hard to be accommodating in hosting entertainments: "If they liked flowers I accommodated them; if paintings, I had some of the rarest; if wines I had every sample of the world's choice; if the menu was the object, nothing was there wanting."[151] Although Cassius was enjoying his political office, Mary Jane was not so content. The cold, bitter Russian climate was not to her liking, and she was extremely homesick. It was decided that she and the children would return to the United States.

Cassius continued on as ambassador until 1862, when an embarrassment within Lincoln's cabinet caused the president to recall Cassius to the States so that he could get Simon Cameron out of there to avoid further humiliation.[152] Lincoln also put Cassius on a special assignment. Clay was to return to his native Kentucky and test the waters on a new policy Lincoln was thinking about that would later become the Emancipation Proclamation.[153] At the time, Kentucky was a border state, was truly an area where brother was against brother, as portions of the state sided with the North while many others went with the South. Lincoln wanted to make sure that such a proclamation would not alienate Kentucky and cause the state to secede with the South.

At this time, Cassius also had a short stint in serving in the war. In late August 1862, General L. Wallace was in command of the Union forces. According to Cassius, Wallace asked Clay to take charge of the company after Clay made the suggestion that the troop plan a defense along the Kentucky River. Never one to back down from an opportunity that could put him in a position of grandeur, Cassius readily agreed and headed out of Lexington with the group of men and weapons. One can almost imagine Cassius shouting, "Follow me boys, I know the way!" as they headed toward Madison County.

Clay's reign as commander was short-lived, as Major General William "Bull" Nelson arrived in Lexington, found out what was going on and rode

in to take control of the troop. It is uncertain whether Clay took power because he was unclear about the chain of command, had the best interest of the company at heart or simply wanted his own wartime glory—possibly all three. In any event, Cassius seemed to take his demotion with grace, if a little disappointment.[154] Had Cassius remained in charge of the infantry, the outcome would probably have been very different. Clay knew the region very well, and his expertise in this area would have provided an advantage for the Union troop. Instead, the company moved southward and became involved in one of the most definitive Confederate victories in the Civil War, the Battle of Richmond. In place of battle on the front, Clay went on to address the House of Representatives concerning the concept of an Emancipation Proclamation. Cassius reported back to Lincoln that Kentucky would stand with the Union should such a decree be made.[155]

Clay was appointed a second term as minister to Russia, and he returned to that country in 1863. In the middle of his tenure, word reached Cassius

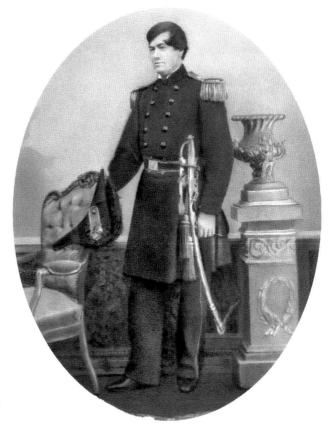

Photograph of Cassius M. Clay in military uniform, circa early 1860s. Notice the sword at Clay's side. This is the same weapon given to Cassius in recognition of his services in the Mexican-American War. *Courtesy of Kentucky Department of Parks.*

that Lincoln had been assassinated. He sent formal condolences to the first lady and continued on at his post until its successful conclusion in 1869. In speaking of Lincoln, Cassius stated:

We all know that Mr. Lincoln was not learned in books; but he had a higher education in actual life than most of his compeers. I have always placed him first of all the men of the times in common sense. He was not a great projector—not a great pioneer—hence not in the first rank of thinkers among men; but, as an observer of men and measures, he was patient, conservative, and of sure conclusions. I do not say that more heroic surgery might not have put down the Rebellion; but it is plain that Lincoln was a man fitted for the leadership at a time when men differed so much about the ends as well as the methods of the war.[156]

Clay went on to state:

But Lincoln was not only wise, but good. He was not only good, but eminently patriotic. He was the most honest man I ever knew. Lincoln's death only added to the grandeur of his figure; and, in all our history, no man will ascend higher on the steep where "Fame's proud temple shines afar."[157]

Cassius was immensely successful as an ambassador to Russia. Clay had great respect for the leaders of that country, and this admiration seems to have been reciprocated. The greatest accomplishment Clay would achieve as minister was his effective negotiations for the purchase of Alaska from Russia for the United States. On March 30, 1867, Alaska would come under United States control, although it would be nearly ninety years before that territory would be admitted as an official state. Clay was justifiably pleased with his involvement in the acquisition and had said that if one thing could be placed on his tombstone, he wanted it to be the word "Alaska."[158] Sadly, this did not occur. What's more, both his birthdate and death date are recorded wrong on his gravestone.[159] Apparently, his children weren't paying much attention.

Cassius served his second appointment as minister without his family by his side. It was decided that Mary Jane and the children would continue on in Kentucky. The younger children, Brutus and Laura, would pursue an education. The oldest son, Green, served overseas as well. The older daughters, Mary Barr and Sarah, assisted their mother and looked out for marriage prospects. The youngest daughter, Ann, was only four when her father returned to Russia; she spent time at home.

Portrait of Czar Alexander II. This was a gift given by the czar to Cassius M. Clay. Cassius had this painting on display in the formal reception hall, where it also hangs today. *Courtesy of Kentucky Department of Parks and Liz Thomas Photography.*

The family kept busy landscaping the yard around the original home. In March 1863, Mary Jane and her two oldest daughters were working hard. Mary Barr had a rockery built where a former building once stood, while Sally worked on having a pool dug. Mary Jane worked on leveling and grading the land around an old well, as well as the carriage road.[160] This all was in preparation for construction to begin on an addition to the family home.

Cassius had set up working plans for his family home of Clermont to be enlarged while he was away. He chose for the architect and engineer Major Thomas Lewinski. Clay knew Lewinski as the latter had assisted Clay in protecting the *True American*.[161] Although a fairly busy architect in the 1840s, by the mid-1850s Lewinski had secured a position as a secretary for the Lexington Gas Company, and by that time he was semi-retired and only ventured into the realm of architecture to oblige friends and former patrons.[162]

The builder was John McMurtry, one of Lexington's most productive architects and builders.[163] McMurtry had trained locally as an apprentice,[164] and he liked to keep things interesting by building structures in various styles rather than sticking to one genre. Said to always have his black stovepipe hat and umbrella in tow, McMurtry was well qualified as he had supervised and built a vast number of homes and buildings in central Kentucky.[165]

Perhaps McMurtry had more of a hand in construction than just as the builder, for in 1887 he claimed that he "designed and superintended Gen. C.M. Clay's residence."[166] Indeed, McMurtry is listed by name in a few Clay family letters, whereas Lewinski is not. It is possible that Lewinski simply produced the initial plans for the addition, and McMurtry took over with any changes that would have been made. Noted Kentucky architect Clay Lancaster thought as much, stating, "Lewinski and McMurtry had worked together closely on many projects, and it is not unlikely that the latter made more than a superintendent's contribution to the final effect."[167]

It is not known just how much input Cassius and Mary Jane had in the final appearance of their home. Most assuredly, Mary Jane would have kept Cassius abreast of each new improvement and solicited his advice. In addition, Cassius's older brother, Brutus Clay, was an advisor to Mary Jane. However, in studying the structure, it is apparent that both the builder and the architect had strong influence on the finished product. The older home had been built in a Georgian style. The new addition would be built in Italianate.

Any knowledge pertaining to the timeline of the building of the addition would not have been possible for those researching the topic today had it not been for Laura Clay. Fortunately for contemporary researchers, Laura Clay, the next-to-youngest daughter, was away at school for the majority of the construction. Laura's mother and siblings wrote letters to her to inform of the progress of the new addition. Although Mary Jane admonished her daughter to "never show any letters to anyone"[168] and in at least a couple of instances instructed Laura to burn her letters,[169] happily the daughter had a sentimental streak and saved them, so that a record still exists that offers a small window into the history of the house.

The foundation for the addition was laid in mid-April 1863. In a letter to her daughter Laura, Mary Jane mentioned, "I may not do more than build the foundation this year."[170] In January 1864, Mary Jane had been told by "the man who undertakes to put it up" (possibly this was Lewinsky or McMurtry or just one of their construction crew)—that the house would be under cover in August.[171]

Mary Jane had extreme faith in her builders. Many modern homeowners who have overseen the construction of a new house have had to endure endless waiting and dragging of the feet of the people they employ. Such was also the case, apparently, in the 1860s. Nearly a year later, in March 1864, the workmen were still toiling on the foundation. Mary Jane mentioned on March 13, 1864, that there were men at work on the foundation. At this point

in time, to Laura she also hinted at the "beautiful improvements" that were made to the yard. However, much to the frustration and disappointment of these particular authors, she "will not mention them but let you enjoy them when you come home."

Mary Jane also stated that the work on the foundation would be finished in two days, weather permitting.[172] The weather must have not permitted. Those two days stretched into a month and a half. In an April 27, 1864 letter, the reader can really feel Mary Jane's frustration when she wrote, "The stone masons left here last Saturday after working only one day & a half on the foundation & only a lick today, losing three days this week…I hope McMurtry will be here tomorrow."[173] Perhaps she was hoping that the builder would set a fire under the other workmen's pants. He might have. A letter from Sarah to her sister Laura two days later stated, "The work on the house is progressing well. The workmen expect to finish the foundation of the house by the first of June."[174] The construction crew kept to this timetable, for on May 23, 1864, Mary Jane stated that the foundation "will be nearly complete next week." It is apparent that after more than a year of dealing with the building, she became pretty burnt out, as she mentioned, "I am not so elated about it as I have been. I hope when Brutus gets here & I get rested some, I may enjoy the prospect of a house, as I have done."[175] Clearly, Mary Jane needed a break.

That break wouldn't come. By early June, Mary Jane complained, "I have had in the last month as many as fifty men here at once in some way or another to be attended to."[176] By mid-November 1864, the first story had been completed, as Brutus Clay related to his sister Laura, "Ma is getting along slowly with her house, but the first story is finished, and she finds that she will have plenty of brick, which takes a great weight from her mind."[177] According to Cassius's grandson, Green Clay, the clay used to make the bricks for the new addition was harvested from the very same pits that yielded the clay for the original house bricks. Green stated, "This accounts for the remarkable blending of color in the outer material used in the old and the new."[178] The brick was laid in American bond style, which would have been the easiest style of brickwork to lay. That's a good thing, as the building would end up being massive. By early December, the second story was up, as the windows were being built in.[179]

In the early part of 1865, the family was still residing in Clermont while overseeing the work being done on the new addition. There was planning done in preparation for the finished home. Mary Barr did some research in Cincinnati, Ohio, for furnishings, carpets and fireplace mantels and

grates.[180] The completion of the second and third floors took place that year, for by October the family had moved somewhat into the new addition. Sarah wrote to Laura from the breakfast room of the home, stating, "The house is torn entirely to pieces, this being the only room in which I can have a fire." Still, the family was making do in the unheated new section, as Sally (how Sarah was known to her family) stated, "We are all sleeping at present in the third story in mine and Mary's room & without glass."

Mid-October in Kentucky can get a bit chilly, and to sleep in bedrooms without windows might not have been ideal, as Sally commented, "You can imagine we are not perfectly comfortable however in a day or two we expect to come down into Ma's and Pa's & the nursery rooms which are now having the glass and grates put into them." Although there were eleven workmen employed in construction at the time, "The house goes on slowly."[181] In December, Laura's sister-in-law Cornelia ("Cornie," as she was known to family and friends) wrote to her from the nursery, describing the progress that had taken place on the home:

> *Ma's House is nearly finished it seems to me, and yet it requires some time yet to do all that needs doing. Ma says she will send the workmen away next week whether they finish or not, until the spring. The painters are here, but they have painted none of the inside work, nor will not this winter, except the library. The girls* [in reference to Laura's sisters Mary Barr and Sarah] *are very anxious to have it finished that they may have a place to sit down in comfort.*[182]

By the turn of the New Year in January 1866, the house had been completed enough for servants to be working in it. Sarah Clay related to her sister Laura that "Lucinda at five dollars cleans bed-rooms and nashes [Sarah probably means ashes, in reference to cleaning out the fireplace grates]. Amelia keeps the rooms down stairs and attends the table for eight."[183] A little later that month, Mary Jane was busy decorating and planning for the upcoming months. She told her daughter:

> *I am cleaning up around the house some & if I can continue at it for two weeks I will be much more comfortable. I hung the portraits* [possibly of either her in-laws Green and Sally or of herself and Cassius] *and candelabras in the dining room & library today & am very much pleased with the arrangement of them. I have Fullilove doing some jobs which the other carpenters left undone which is making me more comfortable.*

White Hall

I must send for the workmen as early in Spring as they can work so as to have the house as nearly complete as possible by the time you and Brutus return home in June.[184]

Also in January, older sister Mary Barr was in Cincinnati, Ohio, purchasing furnishings for the new house. These items may have been the same ones she was researching the previous year, as among her purchases were bedroom furniture, rugs, carpeting and fireplace mantels.[185]

These mantels would be mainly for show. One progressive invention that was incorporated into the house was the central heating system. This was a concept that the family encountered while in Russia. Kentuckians at the time had to deal with messy, inefficient fireplaces—soot and ash would be everywhere. A great deal of the heat (but unfortunately not so much of the smoke) was lost out of the flues. Russia, being a colder climate, had perfected a heating system in order to adapt to the frigid temperatures. In a letter back to a friend, Laura discussed the appearance of the heating vents, which were adopted for White Hall: "The fireplaces are made in a kind of furnace which is made to resemble marble."[186] In addition, Mary Jane, while in Russia in 1861, wrote back to her sister Jule on the process of how the heating system worked where she was living, "The heat is shut off…a tight-fitting cap is placed over the chimney, a hole is opened in the wall of the room & the heat rushes from the chimney into the room."[187]

This type of system apparently worked extremely well. Mary Jane stated, "In the morning the rooms are entirely pleasant to get up when one chooses without waiting to have a fire made."[188] In the same letter, Mary Jane also speculated on the construction of such a system, saying, "I suppose furnaces are built on the same principle tho' & preferable on account of being in the cellar & only needing one fire for the whole house. Whether the heat can all entirely be thrown into the house or not is a question for me. Can it be or not? If ever we build I hope to have a furnace for the whole house."[189]

Mary Jane's hope became reality. The mansion had two furnaces that would have burned coal, wood or both installed into the basement. Ductwork was incorporated into the walls of the new section. The hot air was forced through this system into the rooms upstairs. Large openings, a lot like modern heating vents today, were in each room for the hot air to come through. There were fireplace mantels installed into the rooms, but these were faux and were too shallow to be used as actual fireplaces. All of the air would have traveled up out of one of two main chimneys in the house. The older section continued with the more archaic wood burning fireplaces.

Indoor plumbing was another modern amenity included in the home that either was influenced by the Clay family's travels overseas or may have been a suggestion of Lewinski's. This particular system was really ingenious, and it is believed to be one of the first of its kind in Kentucky. The plumbing was gravity fed. Water was collected from the gutters on the roof. It then traveled down through a pipe or pipes into a large storage tank, located on the third floor. From that cistern, the water passed through one of three pipes into three different rooms below on the second floor. The first room contained a toilet. The second room's actual usage is not entirely known,[190] but the authors believe to be a wastewater disposal area for chamber pots, dirty washbowl water and other similar refuse. The third room contained a bathing tub with a shower.

Although considered odd by modern standards, having three separate rooms rather than all of the bathing necessities in one room made great sense. The tank above could hold an immense amount of heavy water, and the three walls separating the rooms would help support that weight. Also, the three divided rooms allowed for more efficient usage of the spaces. One family member could use the necessities while another was able to bathe in privacy.

The incorporation of the indoor plumbing was completed sometime in 1866, or perhaps even later. The one reference that has been found concerning the system was made by Mary Jane in an April 27, 1866 letter to her daughter Laura. In the letter, Mary Jane mentioned that she "will go on to complete the house as fast as I can get the workmen to do it, except the cistern & bath room & closets connected with it. We can be comfortable without that being done so will wait on more convenient season."[191] As accustomed to modern indoor plumbing as contemporary society is, perhaps this statement might not seem to make sense. Virtually no one today would consider a home complete without a functioning bathroom. The Clay family, like most people up until this point, would have used portable baths, called hip tubs or hip baths, for bathing. (The newly installed permanent bathtub would be much larger than these more moveable baths.) Answering nature's call would have been done in a small building or buildings located behind the main house (referred to as the "Mrs. Jones" by one Clay daughter).[192] Should the need arise in the middle of the night or on some cold and snowy day, one could also employ the services of chamber pots, which the Clay family most certainly had. The indoor bathrooms were definitely a luxury, not a necessity.

It is a common misconception of modern society that those in the past did not bathe regularly. Personal hygiene at that time had a lot to do with opportunity, social standing and one's own viewpoints concerning the

subject. Mary Jane wrote to her daughters admonishing them to be clean and to change their underclothes regularly.[193] In addition, the family felt that a cold bath was good for the constitution.[194]

A unique feature to the home is the number of closets the house contains. It was not a normal practice for a home in the 1860s to contain closets. Most people at the time stored their clothing and linens in wardrobes or armoires. The mansion contains two closets in nearly every bedroom, and the master bedroom contains three closets. All together there are seventeen closets in the home if one includes the bathroom spaces as three separate closet spaces, and Mary Jane did, as she refers to them as closets.[195]

The actual usage of the bedroom closets is unknown, as the Clay family is surprisingly mute on the subject. One can make educated guesses as to the purpose of such rooms. The closets could have been used like one does today, with the spaces being for clothing storage. Perhaps Mary Jane was making a reference to this when she told Laura in a May 1864 letter, "After a while we will have <u>plenty of room for our clothes</u>. Will that not be charming?"[196] White Hall does not have a useable attic, and so the rooms could have been for extra storage. When traveling in the 1860s, one did not use the small and efficient luggage that is a staple of today's society. Instead, large trunks would have been utilized. A portion of the closet space could have been employed for the storage of these traveling chests. Also, at the time, if one had personal slaves, those slaves stayed near a person, even at night, in case the owner needed anything. The rooms are large enough to have been a sleeping space for a person.

In the spring of 1866, Mary Jane was still busy working on the outside features to the home and yard. In March, Mary Jane moved the yard gate at McMurtry's suggestion. She was "delighted" by its placement. The new addition essentially was built above and around the former house, keeping Clermont intact by literally wrapping around the original structure. The southern-facing porch to the main entrance of Clermont was enclosed in glass and made into a conservatory or sun porch. The main entrance to the new addition now faced east, a fact that Mary Jane was proud of and pleased with. She stated, "The yard appears to fine advantage which it never did before & the house produces a much finer effect, from the side toward Green's. [This is in reference to Mary Jane's son Green Clay's farm.] The house appears to greater advantage than any other position & from the lumber house I think it is beautiful." At this same time, Mary Jane was also working at removing all of the litter made by the building from around the mansion and was in the process of getting brick and stone to lay out

the carriage path. All the work and hassle had been worth the wait; she went on to state, "I do enjoy my house so much, even in its unfinished state, it is a pleasure to me."[197] Later, Mary Jane gushed, "I am now delighted with my yard for the first time. The change in the entrance is the greatest improvement. It is beautiful!"[198]

Despite her delight, Mary Jane was still working with both ends of her candle burning. She became worn down from all of her responsibilities and confided to Laura, "I hope your Father will be content to come home & attend to his peculiar duties & allow me to attend to mine only, for which I would be truly thankful."[199] In April 1866, she relayed to Laura, "I am so weary, or lazy, or something, that I do not feel inclined to go out of the yard at all & I feel all the time that I will rest myself after each job is completed but each one is so long being completed that other things are pushing to be done continually."[200] In another letter, Mary Jane seemed close to despair when she said, "Oh! My life is all toil!"[201]

In addition, Mary Jane felt that she could not deal with the family business as she should when her attentions were devoted to the progress on the house and yard. In another letter, also written in March 1866, Mary Jane related:

> *I am very busy having the yard cleaned & laying out the carriage drive. I feel that I am neglecting every business to this pleasure. I feel that I am getting lazy about business & it is becoming very irksome to me. I am yet without workmen but am anxious to have the stonemason come & finish the work & would like the plasterer to come as soon as practicable to finish his job. Sally wrote to your Pa to send us carpeting for all the house & he answers that he will so perhaps we may get the house carpeted. If he can do it without going into debt I will be very glad for it would be very uncomfortable looking to have naked floors for years. I shall add furniture very shortly. I feel very comfortable now, I suppose it is the result of having been so uncomfortable for so long.[202]*

The drudgery continued for Mary Jane: "Feely & two other stone masons are here at work & I believe all the stone work will be completed next week. Then I will send for plasterers & then another stone mason to lay the floor of the vestibule & portico, after which I do not calculate upon having any other workmen." Even without outside workers, Mary Jane intended to keep going: "I may be able to get the pantry papered & painted this spring but will attempt nothing now. Your Father will send some carpeting for halls & stairs, all other furniture we can do without & will furnish as we can afford it."[203]

She may have been weary, but Mary Jane still enjoyed watching the progress on her home. She mentioned in a late April 1866 letter, "I am much entertained just now in having the terraces made by two good Irishmen & Jerry is dressing up the walks & flower beds." She added, "I will have these Irishmen to lay stone on the carriage drive as soon as they finish the terrace & clean out the cellars." She concluded, "It is all beautiful and delightful; if I can afford to keep it in order, I will be much gratified."[204]

The reader can glean from just these excerpts of letters that money was an issue for the Clays. Viewers today of the palatial mansion might get the impression that the family had an endless supply, but this was not the case. Cassius did get a stipend as minister. This he used where he could at home, but he was also expected to maintain a certain standard as a United States ambassador. In one such letter, Cassius related home to his wife, "I do deny myself a great many things here: but you must remember that the government give me a certain salary to maintain a certain degree of respectability here: which I cannot forego by turning every thing to private account. Almost all ministers from our country spend salary: and private fortune both."[205]

In this letter, Clay also denied a pleasure trip for their daughter Sally, stating that he didn't think it was prudent of Mary Jane to spend money on something so frivolous "when you have not a bed hardly to give her, when she is married!"[206] He needn't have bothered; Mary Jane knew that the bills were accruing. Family letters are peppered with references to money and making "ends meet."[207] One way was to sell cash crops and raise livestock in the effort to bring in more money. In an undated letter (probably circa 1866), Mary Jane bemoaned to Laura, "I sent my sheep to market & did not get half as much money as I expected from them and as I have still such heavy bills to pay for erecting our home it greatly distresses me for I have yet to furnish it, which I despair of doing so for a long time yet."[208] There was the prospect of a lucrative investment in the oil industry; in the same letter, Mary Jane mentioned that "I am now hoping for a great, great success in our oil speculation. If it succeeds, all will go merry as a marriage ball. Hope is a great comforter."[209] Hope was all she had, for although other letters between family members mentioned the wished for oil payday, it must have never occurred. There is no record of the Clay family striking it rich with the "black gold" or "Texas tea"—or of them "moving to Beverly."[210]

By the late 1860s or early 1870s, the mansion would have been on the back end of completion. It took nearly a decade to finish and transformed a modest seven-room home into a forty-four-room mansion. Any guest visiting the estate would have been greeted by two massive wooden front doors that

opened to reveal a main hallway large enough to intimidate horizontally and vertically, with its stretching length and sixteen-foot ceilings complete with decorative frieze work. The curving main staircase leading to the second floor would have evoked admiration in all but the most jaded of callers. To the side of the staircase was a room made to access the space underneath the stairs. Perhaps this could have been employed as a cloakroom or general receiving area, as this smaller space was also meant to impress, with plaster frieze work in a fruit pattern incorporated into the ceiling decoration.

Should one be so lucky, the visitor might be invited into the awe-inspiring drawing room, which continued with the sixteen-foot ceiling height and included two towering Corinthian columns, with decorative plaster frieze work located on the upper portion of the pillars, encircling the entire ceiling, as well as a medallion above the chandelier. A back hallway that included a staircase leading to the second floor, a set of stairs that went to the basement and a small closet would have been hidden from view by a massive door. Originally, the house had a parlor, a dining room and a study or second parlor on the first floor. At completion, the parlor was turned into a dining room, the study or second parlor became a library with floor-to-ceiling glass-covered bookshelves and the old dining room became a breakfast room and pantry, with a closet added in the southeast corner of the room.[211]

If the visitor was an overnight guest, he or she would ascend the stairs and would have probably spent a pleasant evening in one of two impressively sized bedrooms, each with a pair of walk-in closets, and he or she would have been able to utilize the modern three-closet bathroom in the back hall. Transom windows were placed over each of the bathroom doors to ensure adequate lighting and airflow. The more private second floor to the old home had been updated as well. The master bedroom, referred to as "Pa's" (Cassius's) room in multiple letters,[212] was nearly tripled in size. A wall was removed between two rooms that had been bedchambers previously, providing a roomier space. Three large transomed closets were added in to the existing original master bedroom, and a large retreat room was incorporated onto the backside of the main staircase and faced the front side of the mansion. The remaining two bedrooms on this floor seem to have not been altered a great deal.

As mentioned previously in a letter, new glass and fireplace grates were installed in the bedrooms. In addition, the stairs that would have led up to the original attic were removed along with a window that would have been in the original hallway. This slightly enlarged one of the bedrooms, while the third room remained the same size. To reach the attic space, the guest

must exit out of the old section of the second floor and travel up a flight of back steps. The attic was transformed into two large rooms. One room had the ceiling raised to a higher level, with new windows installed, while the other room maintained the lower ceiling with sloping sides that would have reflected the original roofline. Because of the low ceiling height, this room could have potentially been used as a storage space.

Continuing on to the third floor, which is the only level of the mansion that was an entirely new addition and does not have any of the existing house incorporated in to it, the guest would view three additional bedrooms, each containing two closets apiece and a massive hallway. Gazing out the windows on the top story, one can get a sense of how tall the structure is, as it towers over the mature trees surrounding the home. To gain an even better view, the guest could step through the front windows of the second and third floors of the addition onto a balcony with beautiful scrollwork.

Should the guest venture into the basement area, he or she would find that a full basement was added in as well, one that would have housed the fireboxes for the heating and served as storage space for coal or wood to feed to the furnaces. There is also a room that could have potentially been used as a wine cellar. At least a portion of the ceilings in the basement were finished; however, the flooring remained dirt.[213]

Behind the mansion, the warming kitchen off of the back porch became the cooking kitchen, while the stone building that once served as loom house and kitchen was converted into a washhouse for laundry.[214]

The surrounding grounds would have been improved as well, with numerous plantings and gardens around the main house. A lover's walk wound its way around the front yard amid roses and honeysuckle. Cherry, peach, apple, cedar, oak and elm trees were on the grounds. A large grape arbor was also present. A grandson remembered, "Ivy vines clung and clambered everywhere."[215] On the corners of the outside of the mansion were placed statues representing the four seasons.[216] There also would have been a number of outbuildings on the property. These would have included a mule barn, a gristmill, an icehouse, a smokehouse, a chicken house, a loom house and laundry,[217] a summer house,[218] a carriage house and barns, just to name a few.

The new structure was referred to as White Hall. Many guests will ask how the name was chosen. In truth, letters written long before the new addition was built had White Hall inscribed in them. This could have been referring to the mailing address, the White Hall District of Madison County. It is possible that the house took its name from the surrounding area.

Engraving of White Hall taken from Cassius M. Clay's *Memoirs*, circa 1880s. Originally engraved by W. Wellstood & Company, New York. *Courtesy of Kentucky Department of Parks.*

Why was such a large house built? There are two different possible reasons for the grand home—a his and hers type of dueling viewpoints. Up to that time, despite the opposition to his views regarding slavery, Cassius M. Clay had an active career in politics. He was a member of the Kentucky House of Representatives in 1835 as a Whig and served as a member of the General Assembly in 1840. Clay was a founding member of the Republican Party and, in 1851, ran unsuccessfully for governor in that faction. By 1860, he was up for the Republican presidential and vice presidential nominations—of those two Cassius was last on the ballot for president, while in the vice presidential race, he rose to number two. Close but no cigar. In 1861, he was made minister to Russia. Later, in 1876, there were some who would have Cassius nominated for vice president again, this time on the Democratic ticket.[219] One may notice that Cassius did not stay too long in one particular party. He stated, "Those who follow principles can not always remain in the same party."[220] Despite his political party hopping, there probably was little cause in Clay's mind that he would not continue in eminence in terms of politics. A large showplace home would be necessary in terms of prestige and hosting lavish parties.

A woman's perspective could be that Mary Jane Clay had a great number of healthy children, whom she probably foresaw as continuing on with even

more healthy children of their own. Perhaps she envisioned a sizeable home filled to the brim with children and grandchildren to keep her company. In any event, if these could have been the reasons for the addition, those dreams of what the home was to be used for never came to fruition. It's probably a good thing she did not have her children and grandchildren with her indefinitely. Years later, she complained that a number of her grandchildren "cannot keep hands or face clean 30 minutes." To keep the annoying offspring out of her hair, "I keep a pie in Mary's [Mary Jane's oldest daughter, Mary Barr] room all the time."[221] A very clever tactic, for who can escape the allure of pie?

Cassius was relieved of his ambassadorial duties in 1869 and traveled back to the United States that same year. He did not, however, return straight home. Cassius took up residence in New York for a time.[222] While residing there, Mary Jane wrote and informed him that she did not want to be buried at the Richmond Cemetery, where he had purchased burial plots for himself and, he presumed, his spouse. She preferred to be interred at the Lexington Cemetery, where her parents were buried and where their deceased children also had been laid to rest.[223] This might have given Cassius a clue as to the state of things within his marriage. If his wife was not willing to be near him in death, she probably didn't want to be around him in life either.

When he made it back to his family in 1870, Cassius received a decidedly less than enthusiastic reception. Rather than have her newly returned husband reside with her in her own room, or in the room that had previously been his, Mary Jane placed all of Cassius's clothes in a third-floor bedroom of the new addition, which, at the time, had no heating as the fireplace was unfinished. Clay claimed that the temperatures were so extreme that he had icicles frozen in his beard when he awoke the next day.[224] Mary Jane gave Cassius the cold shoulder in the truest sense of the word.

The couple was not always so estranged. Throughout their forty-five years of married life, the Clays had their share of ups and downs. In a letter written by Cassius to Mary Jane on December 29, 1850, some twenty years earlier, one can see the deep love Clay had for his wife when he concludes his letter saying:

> *How is it—does my pride no longer lead me to conceal my feelings, or am I indeed more in love with you at forty than at 23! But so it is—I feel more "foolish" about you now, than ever before in my life! Can it be that I have more tried life—its fame—its splendor—its wonders—and am more and more convinced that happiness can only be found in one loved one—or am*

I more in love with your character, than I was once with your person!—But this I know—that now—I pour out my soul at your shrine—and when absent fear that envious fate may prevent the realization of the bliss of our reunion—forgive my silliness and believe me

Ever yours only
CM Clay[225]

What would cause a union that had been so loving to go wrong? It does take two to make a marriage work, and the fault should not be placed on one individual or the other. Generally, it is not one specific reason that causes the collapse but rather a number of factors, and such was the case with Cassius and Mary Jane's marriage.

The unfaithfulness of a spouse can certainly cause a marriage to crumble, and this might have played a role in the demise of this couple's marriage. Cassius claimed that Mary Jane was the first to make the "breach upon the marriage duties."[226] While some might interpret this to mean that Mary Jane was untrue to Cassius in a sexual way, there has never been any proof to this claim. Indeed, Cassius did not intend for others to think this, as he challenged an individual to a duel once when he erroneously made this assumption.[227] Indeed, in a letter to his publisher, Clay stated, "No one this side of the Mason & Dixon's line ever hinted at such a meaning as the breach of the 7th Commandment on the part of Mrs. C."[228] Perhaps, then, Cassius is referring to the fact that he expected Mary Jane to return to Russia with him when he took a second term as minister in 1863, and she preferred to stay in Kentucky.

There are, however, numerous instances in which the fickle finger of unfaithfulness can be pointed at Cassius. In 1845, Cassius claimed that he threw away his wedding ring.[229] A year later, while held captive in Mexico, he would sneak out of his prison to visit a young Mexican girl by the name of Lolu. Alas for Cassius, this tryst may not have ended as he had hoped, for he stated rather dejectedly in his *Memoirs* that Lolu chose to kiss her pet parrot, Leta, rather than him.[230] Years later, Clay stated in an interview in reference to his marriage to Mary Jane, "I was practically divorced long before it took legal shape, therefore I considered myself free to love anybody."[231]

Money issues also often contribute to divorce, and the Clays were no exception to this. As seen through the excerpts included in this book thus far, money and the lack thereof were indeed problems. One such letter written by Cassius to Mary Jane in October 1865 dealt specifically with debts:

White Hall

Dear Mary Jane,

Your letter of the 24 Sept. is received. And as you have so much to ____ think of, I conclude to make this letter particularly a <u>business letter</u> so that you can file it, and refer to it: for I see you forget always what I say on these subjects.

1. In reference to sending you more money: I wrote you early this spring, that I had invested my spare money in speculation and could send you <u>none</u> this year, and probably no more during my ministry here.

2. Brutus [Cassius's brother] *relinquished his lien upon our estate upon the conditions that we would go on steadily to pay him off. This is the 5ᵗʰ year, I desire you therefore as my agent to pay off the balance of this debt. Then you can do as you please with the property, always reserving us a child's portion of the estate.*

3. There is money coming to me from the Hector Lewis Estate. James Garrad, the executor, and Charles Garrad of Bourbon security. The records are in the Fayette County Court. <u>Collect It.</u>

4. Continue to pay my taxes on my lands in Iowa & Minnesota and the "Glade" land in Madison County.

5. I have cattle with Brutus—½ of the increase is mine, the balance of the increase his, for keeping them.

6. Place my deeds in special deposit in the Na Bank of Kentucky of Ky. at Lexington.

7. Keep out of debt: then if you have any thing to spare—spend it as you like. In my opinion there is to be a "crack" in monied matters yet as prosperous as times seem!

8. In regard to carpeting and ornaments for the house etc. I shall not aid you in that: because I have a great deal of furniture here which I shall bring home. Paintings, statues, and chairs & carpets and window curtains. Till those are placed we don't know what more we shall want: and it is better to have an unfurnished house than <u>none</u>! We are too old now to recover from new debts, and will have no family to help us again.

9. Green [Cassius and Mary Jane's older son] *ought now to take care of himself: but you can do as you please with your own: after you pay my debt to B.J.* Clay [Cassius's brother, whom he referred to earlier in the letter].

10. I desire Brutus [Cassius and Mary Jane's younger son] *to be kept at school till I say quit, I don't want him to receive the reproach of "illitraite" from any body.*

11. I am opposed to Laura's being in a boarding school—you may act however as you like in that.

12. I am trying to make provisions myself to pay off the debt to the "contingent" fund of my father's estate, and may legalize to the girls—my sisters. I shall never die happy if I am in debt to any one!

Having ____ way would I close this letter asking you to read it occasionally, to refresh your memory. You have two estates your own, and mine: and you must live upon them—or suffer.

Kiss Annie & give my love to all the children.
Yours ever, C.M. Clay[232]

It is clear from this letter that Cassius desired his wife to pay off the family's existing debts and to live within their means. Clay would have had extensive experience when it came to debt management, or lack thereof. He suffered many setbacks involving his finances throughout his life, including going bankrupt.[233] Despite Clay's wisdom and advice of keeping debts to a minimum, Mary Jane was not as good a steward of the finances as Cassius requested.

Questions concerning finances and fidelity came to a head one evening when Cassius and Mary Jane sat down to look at their budget. Cassius had allotted Mary Jane $8,000 to build onto the existing house. When all was said and done, the construction expenses mounted up to over four times the initial amount, an estimate of more than $30,000.[234] Cassius stated that he had already paid for the cost of the materials used in building the home[235] and, upon learning the total, probably was shocked and appalled by this price tag. It is the authors' belief that upon accusations from Cassius, Mary Jane could have pulled out the October 21, 1865 letter, for an inscription written on the outside of the letter by Mary Jane stated, "Gives permission to do anything with the property I choose after paying B.J. Clay's debt."[236] In the way that women are capable of, she probably brought to his attention that he had given her a free hand. This is, of course, speculation on the writers' part. What is known about this particular meeting is that Cassius accounted for all of the money that had been sent to his wife while he was away, and Mary Jane in turn offered to pay him back. Clay refused this suggestion. It seems at this point that the discussion took a turn for the worse. Mary Jane went from defending her purchases in Clay's absence to questioning Clay about his activities while oversees.[237]

There were a few instances while Cassius M. Clay was in Russia in which his foreign peers might have misconstrued his actions. In reality, Clay was

attempting to be a southern gentleman. However, certain behaviors that at that time in the United States would have been considered chivalrous were major breeches in appropriate conduct in Russia.

One such incident occurred on a day when Clay was invited by the emperor to one of the summer resorts. The emperor had provided one of his own carriages to transport Cassius to the resort, and on the way there, Clay passed by Princess Louise Suwarrow, who happened to be staying at the resort with her husband. No husband was in sight with the princess; instead, she had a female attendant and some footmen with her. The company had decided to row a boat on the nearby lake. A chilly summer rain came upon them, and since the princess had no coat, Clay gallantly offered for her to use the emperor's carriage and to drive home with her attendant. Clay had trouble understanding why the princess was reluctant to do so, but in the end she took his offer and went home. Cassius waited under the trees until the carriage returned for him, and then he made his own way back to the palace. Later, Clay discovered that he had committed a great faux pas, as the noblewoman was seen driving home in the emperor's carriage with no reason given as to why she should be in it. Human nature is naturally spiteful, and when no reason is given, others are only too happy to supply one, and most of the time, that reason will be exceedingly unflattering. According to Cassius, the empress never forgave Clay for this blunder and was not quite as welcoming to him after this.[238]

Cassius must have been a medieval knight in another lifetime, as he couldn't seem to stop himself from coming to the aid of ladies in distress. Unfortunately, Clay ended up getting himself involved in an even worse quagmire when he attempted to assist a woman by the name of Eliza Chautems. Perhaps Clay first became acquainted with Mrs. Chautems and her two daughters by dining at the restaurant that they owned in St. Petersburg (the husband, Jean Chautems, was the cook for the establishment). Mrs. Chautems must not have been a very good businesswoman, or her husband's culinary creations were not that appetizing, for her eatery failed. Upon hearing that she had been placed in prison for her debts, Clay, along with another gentleman by the name of John Saville Lumley, rushed to her aid (on white horses, no doubt). Both men gave Chautems money; Cassius's amount was to pay for the rent on a house and furniture to go in it. Mrs. Chautems thanked the men and promised to pay them back. Clay later discovered that Chautems and her family were selling the furniture and other household effects that Cassius's money purchased for their own profit. Upon hearing this, Cassius contacted the police and evicted them

from the house. He then sold the furniture to help pay the debt that the family owed him.[239]

In retaliation, Mrs. Chautems resorted to blackmail, starting with suing Clay in the Russian court system. This ploy was foiled when Russian authorities ordered her to be sent out of the empire, as Mrs. Chautems was originally from Ireland—she also had a bad reputation that preceded her. The British ambassador stopped her deportation from happening, and so Chautems went on with Plan B. If she couldn't get Russia interested in her story, perhaps the United States would be more accommodating. Writing a letter, she sobbingly informed Congress that Clay had pretty much swooped in and rescued her for his own darker devices. She claimed that Cassius had designs on not only herself but also her older daughter, who was thirteen years old at the time. She also alleged that Clay stole her jewels and broke into her house and assaulted her.[240]

Cassius sent these charges along with his denials and a letter of resignation to Prince Gortchacow, asking for the Russian court to take him to trial to let Clay prove his innocence that way. This was all brushed aside. The Russians felt that he was an innocent party who was being taken advantage of through what he thought were good deeds.[241]

Mary Jane may have thought otherwise. The affair had made its sordid way across the Atlantic to the local newspapers.[242] Mary Jane wrote to Cassius questioning him on the scandal. Clay took offense and stopped writing to her.[243] We may never really know whether there was more to the incident than what Clay claims. Whether there was a grain of truth to the allegations or not, they did have a great impact on Cassius, for he went on for a whole chapter in his *Memoirs* about the affair, including numerous letters defending his honor.

Also in his *Memoirs*, Cassius claimed a long list of grievances against his wife, including that Mary Jane cut down all of his ornamental trees, did not put a suitable roof on the house and (in one of the more absurd claims) did not pay him any rent.[244] Clay could have been referring to tenants renting the grounds, or then again, he might have been signifying his own wife's occupancy. When a friend had asked Cassius to reconcile with his wife, he pointed to the top balcony of White Hall and stated, "Do you see that balcony? I would rather jump off from that, and be dashed to pieces, than again marry that woman!"[245] In the end, Mary Jane felt like she would have a better life in Lexington rather than White Hall. She left in 1872, and Cassius filed for divorce in 1878 on grounds of desertion.[246] Mary Jane would not marry again.[247] Instead, possibly because of her experiences with

Cassius and her divorce, she (along with all of her daughters) would become an advocate for women's rights.[248]

Mary Jane would also continue as a fruitful businesswoman, successfully running her own farm, using the experience she surely had gained from managing the family farm in Clay's absence. Cassius may have been uncomplimentary of her, but in truth Mary Jane did a great deal of work while he was away in Russia. She singlehandedly managed to take care of their children, run the family estate and oversee massive construction on their house, all during the Civil War. This was made doubly hard, for supplies and workers would have been scarce, and since Cassius wasn't the most liked man around, the family was consistently terrorized by threats ranging from horse thieves to arsonists.[249] Regardless of the terrorization, Mary Jane ran a lucrative business trafficking mules for the Union army.[250] Without a doubt, White Hall certainly would not be here today had it not been for the business savvy and bravery of this woman.

Perhaps Mary Jane's claims of infidelity had some virtue, for shortly after her departure to Lexington, a young boy arrived in Richmond. Cassius picked up the child at the local train station and took him to White Hall.[251] He changed his name and legally adopted him.[252] Thereafter, White Hall was home, and Cassius was his father.

Thus began a debate that continues on even today about Cassius's adopted son Launey Clay's parentage. Cassius stated in his *Memoirs*, "In the great city of St. Petersburg, of now near a million people—that city of isolation, infinite intrigues, and silence—was born, in the year 1866, a male child. To the secret of his parentage I am the only living witness—I who have, of all men living, the best reason to know—and that secret will die with me."[253] Some claim that Cassius was just that, an adoptive parent and nothing more, while others (including the authors) maintain that Cassius had direct blood ties to the boy. Speculation also has risen about who Launey's parents could be if the father is not Cassius. These thoughts range to a royal conspiracy of the child being an illegitimate offspring of noblemen ranging from Prince Gortchacow (whose ears resemble Launey's) to the imperial family themselves. Others believe that Cassius could have been covering for his own son Green's indiscretions.

Regardless of all of these hypotheses, there are still Cassius M. Clay's own words to study on the subject. In reference to Launey's mother, Clay stated, "The next woman I loved was the mother of my adopted son Launey, but as what I had to say about him has already been published in my memoirs, I never expect to open that question again unless I am forced."[254] This would

lead one to believe, then, that Cassius adopted Launey not out of obligation to a close friend or relative's transgressions, but rather because of the feelings he had for the mother of the child. If Clay had loved the mother of Launey, than perhaps he himself was the father of the child. In an interview he gave in 1894, Clay stated, "When I brought home from Russia with me the child who is now known as Lonnie [*sic*] Clay, I did not do as others have done—disown my own flesh and blood—but I had that child adopted and made him the equal of my other children as heir to this estate."[255] This declaration would seem to clearly state that Launey was Clay's actual son.

Clay continued on living in his massive house, with Launey and the occasional servant to keep him company. Soon enough, Launey would grow up and travel away to school, leaving the aging man to himself. In his own words, Clay "drifted out of politics" and read a great deal.[256] Cassius also stated that he "sought companionship" with plants and livestock. He also had dogs and fish, and he fed the wild birds. During the day, Cassius may have been able to put up a front of happiness, but "at night I was left all the more alone—till I often opened wide the shutters that the bats should enter to pick the flies, as is their wont, from the walls; and their fluttering—life—life—was a pleasure to me."[257] Because he was so lonely, it is only natural that Clay would search for someone with whom to share his life.

Cassius had always had an eye for a pretty lady, and as he got older, his taste in women got decidedly younger. Clay mentioned that he had at least four romances (or aspirations) with those of the female persuasion before settling down to married life once again. Perhaps these earlier relationships did not succeed because the objects of his affection all ranged in age from fifteen to sixteen years old. Some discussions were broken off by outraged parents and families, while in other instances it was the young lady herself who discontinued the relationship.[258]

After a long string of unsuccessful courtships, Cassius finally settled down with a young lady by the name of Dora Richardson. Dora was the sister of a tenant farmer of Clay's, which is probably how he came to know her. She was essentially an orphan and had the unfortunate circumstance of being a witness to her own mother's death by train. Her heroic actions in an effort to save her brother in that instance had impressed Cassius.[259] Her long red hair and glowing skin impressed him even more.[260] It is unclear whether Dora really felt any love for Clay more than as a fatherly figure, but she did accept his proposal, and the two were married on November 13, 1894,[261] much to the chagrin of Madison Countians in general and Clay's own children in particular.

Cassius's marriage would cause national headlines,[262] as the groomsman was eighty-four years old at the time, while his blushing bride was anywhere from thirteen to fifteen years of age.[263] It is interesting that the marriage caused so much controversy, as the legal marriage age of a girl in Kentucky at the time was actually twelve years old.[264] Perhaps it was the vast difference in the ages that caused such uproar. On the day of their marriage, a reporter came out from a local newspaper and interviewed a welcoming Cassius. At one point, he requested an audience with Clay's new bride so that he could record her image. This was refused, as she "never had a picture taken and I will not allow her to have one taken until she is fixed up with nice clothes and her hair is properly dressed."[265] Clay did, however, graciously offer to have his own picture taken in its stead.[266]

Cassius welcomed reporters but not the posse that was sent out to White Hall in the effort to rescue Dora, as many felt that she was being held against her will. Cassius met the group on his own front porch and informed them

Photograph of Cassius M. Clay in the drawing room of White Hall. This image is believed to have been taken on Clay's second wedding day, circa 1894. *Courtesy of Kentucky Department of Parks.*

that he had "[n]ever had to detain a lady against her will." Dora herself called down from one of the upper balconies and said that she was there because she wanted to be and not because she was being held hostage. The posse then moved on peaceably. It didn't hurt matters that Cassius had a cannon loaded and was ready to fire at them if the posse gave him any issues—luckily they didn't. Numerous stories abound about this particular incident.[267] Many claim that Cassius did open fire on the posse.[268] However, in an interview the following day, Clay stated that he had not fired his canon and speculated on the many funerals that would have occurred had he used the weapon.

Unfortunately, a long and happy marriage was not in the stars for the couple. They were only wed for four years, and two and half of those years Dora was separated from Clay. They still wrote loving letters back and forth to each other, Dora's generally asking for money and Clay's generally giving it and warning her against the "vendetta."[269] Finally, on September 10, 1898,[270] the old general gave in to the inevitable and granted his young wife a divorce. Dora would later return to White Hall[271] and serve as Clay's

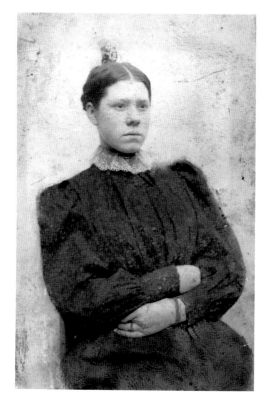

Photograph of Dora Richardson Clay, circa 1890s. *Courtesy of Kentucky Department of Parks.*

housekeeper, while her new husband, Riley Brock, worked as a maintenance man for his wife's former husband. The young couple even named their child after Cassius.[272]

After his separation and then divorce from his young wife, Clay could have easily married again, as he received numerous marriage proposals.[273] Clay chose, however, to only have the occasional servant at White Hall, and he pretty much led a solitary existence at White Hall in his later years. Despite this, Cassius's life was not totally devoid of company.

Clay's fame was still running strong in his twilight years, and numerous newspaper reporters ventured to the lion's den[274] in order to capture an interesting story. Through these interviews, the modern reader is able to get a glimpse of how White Hall appeared in the 1880s and 1890s. Cassius had kept active with his crops and livestock. He had divided his acreage up between his children[275] and left 360 acres for himself. This he sowed with corn, wheat, timothy, blue grasses and clover. The land that wasn't being used for food crops or for haying was kept wooded. Cassius claimed that the 30 acres surrounding his house were landscaped.[276] A correspondent verified this when describing his visit to White Hall: "Forest and orchard trees and shrubs surrounded the house, or mansion, for such it really is. To the west is a sweep of 'bluegrass.' At the east side are low lands from which came the tinkling of sheep bells."[277]

Clay stated in this interview that he had four hundred Southdown sheep, which he preferred to the Merino sheep that his father had raised. In another unfortunate choice of words, much like his father being a "great lover of sheep,"[278] Cassius stated, "You city people might think it curious when I say that my sheep give me a great deal of comfort."[279] In Clay's defense, he was spending a lot of time alone. Cassius would continue raising his sheep until 1902, when they were sold at auction.[280]

Clay was also quite the gardener and would feed his visitors a variety of homegrown delights in addition to meat from his livestock. At one point, he told a guest reporter that "everything on his table, with the exception of the pepper, the salt, and the coffee, had been raised by him on his farm and that he felt happy and independent."[281] Clay was known for raising prized watermelons, even writing an article on the subject.[282] He would often offer a sampling of this fruit to his guests.[283] One reporter on a visit recalled, "He is famed for his watermelons, and on the inside of the hall near the door I noted at least a score of great melons, some of which were four feet long and about eighteen inches in diameter. I found them as sweet as they looked."[284] Clay would impart that the best watermelons never went into

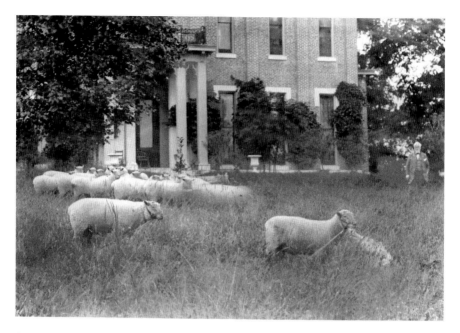

Photograph of Cassius M. Clay standing to the side of White Hall with some of his beloved Southdown sheep. *Courtesy of Berea College Archives.*

town to sale—their rinds were so thin they would crack during shipment and become ruined.[285]

In addition to the grounds, writers also commented on the mansion and its furnishings. One newsperson noted that Joel T. Hart busts of Henry Clay and Horace Greeley were located in the niches on the front porch of the mansion.[286] Upon entering the front hallway, the immense size was commented on by the reporter, who stated that it was so wide "you could turn a wagon load of hay about in it without touching the walls."[287] The reporter went on to describe the furnishings of the hall: "It is furnished with sofas and chairs, none of which are less than one hundred years old, and upon its walls hang works of art by famous European painters. Gortchakoff and the Empress of Russia look down upon you from the left as you enter, and on the right you see a magnificent painting by the Landseer of Russia of the Czar Alexander II riding in a sleigh."[288]

Another writer described the drawing room with its chandelier, sconces and large mirrors, stating that "[t]he walls are adorned with the paintings of the masters, and all that can add beauty and effect is present."[289] By 1903, Cassius would cease to occupy the upper floors of his great home, leaving them empty, instead residing in one room on the first floor.[290]

Photograph of the drawing room of White Hall. This is the only known image to exist showing a full room of White Hall during Cassius M. Clay's occupancy, circa 1894. Cassius is seen seated at the left of the column. It is believed that Dora Richardson Clay is to Clay's left. Although it appears like there is a coffin in the foreground, the piece is actually a bench. *Courtesy of Kentucky Department of Parks.*

Not all of Clay's guests were invited or welcomed. Cassius had had so many death threats and had been in so many life-threatening fights in his lifetime that by the time he got older, he still felt that everyone was out to get him. He would take to writing letters to the local sheriff, urging him to come to White Hall as the "vendetta" was coming to get him. Who knows who or what the vendetta actually was. In many cases, it was likely just figments of the old man's imagination. There was one night, however, when the threat was real.

Three men broke in through the sun porch with the intention of killing and robbing Cassius. They made their way into the library to discover that the weak, elderly, defenseless man they were searching for was actually a well-armed and capable defender of his estate. One man was shot as he entered the room and lay dying on the library floor while Cassius stabbed the second man with one of his Bowie knives. Although this man made it outside the home, he was found dead near the icehouse. The third man was

lucky enough to get away with his life.[291] The sheriff had been sent a note that the "vendetta" was coming. He arrived after the fight took place to find Cassius sitting beside the fire in his library. The only thing that appeared to be wrong with Cassius was that the bottom of his dressing gown was singed, where he had fallen into the fire while fighting. What makes this story even more remarkable is that by this point in time Cassius had gout so severe that he did not have a bedroom upstairs; rather, he used the library (where the intruders broke in) as his sleeping area. In addition, Cassius fought off these three men at the advanced age of eighty-nine years old.[292]

Two years later, Cassius caused even more excitement for the community and headlines for the papers when he had a standoff with the local law enforcement. Clay had invited his oldest daughter, Mary Barr Clay, to live with him. In a change of heart (or perhaps a befuddled mind), he ordered her out of his house.[293] She went but had the sheriff stop by a day or two later for her furniture. What occurred then was like a scene from a western movie, complete with showdowns and shootouts.[294] This inciting story provided front-page fodder for newspapers for almost a week. One paper jokingly referred to the altercations as Cassius simply "spring housecleaning."[295] Each day, the progress of the sheriff was recorded, and in the end, Cassius was the victor.[296] It has always been a case of wonder whether Mary Barr ever did get her furniture back while her father was still alive. She did wind up getting paid for the value of her possessions.

After a month of trying, the sheriff finally succeeded in serving Clay with a writ of attachment for $1,200.[297] It was probably because of instances like this one that Clay's children on July 8, 1903, had him declared "of unsound mind."[298] Cassius's revolver and Bowie knife were taken from him by his nurse. Understandably, Clay took offense.[299] Cassius without his weapons felt perhaps like an ordinary person without his clothes—naked and defenseless without them.

Cassius continued to provide fodder for the papers even in the final days of his life. The pope at the time was also in failing health, and Kentucky papers wondered who would be the first to succumb to the inevitable. In the end, it was Pope Leo XIII who passed away first.[300] In every challenge of his life, Cassius came away the winner, and this was no exception; he probably took grim satisfaction in outlasting the holy man.[301] Cassius would not be the victor forever, though. He could beat people but not the enlarged prostate that resulted in acute renal failure. Amid a stormy night on July 22, 1903, Cassius Marcellus Clay peacefully passed away in the library of the home. He was just three months shy of his ninety-third birthday.

Thus a whole era passed out of existence. Accolades abounded in the newspapers after Clay's death. One editor wrote, "He was a man seen but once and a character known to all. He, more than any other one man, stood for the world's idea of a Kentuckian—bold, fearless, generous, kind, quick to avenge and insult and equally quick to forgive a wrong, an orator and a hand-to-hand fighter."[302]

Cassius M. Clay's funeral took place at the First Baptist Church in Richmond, Kentucky.[303] Conducted by Reverend Timberlake, the service was considered one of the largest attended memorial services that Madison County had seen in some years. Among the many mourners were Clay's children and grandchildren—family who had been estranged from Clay for many years due to the fact that Cassius thought they were his enemies and were out to get him. Clay was buried at Richmond Cemetery, and the burial was very simple, with a plain coffin, as Cassius had stated that only $100 should go toward the expense of his funeral.[304]

As a testament to Clay's antislavery work, mourners at his death included both the white and African American population. A contemporary newspaper commented, "Never was a more striking scene witnessed on the way to Richmond, where the funeral services were to be held. From every humble negro cottage along the roadside and at every cross roads, the mothers and large children carrying those who were too little to walk, the negroes were lined up to pay their last respects to the man whom they honored as the Abraham Lincoln of Kentucky."[305]

Perhaps one of the best descriptions of Clay came from the man himself. Once, Cassius had a friend assist him in composing a will. Clay began dictating his thoughts, "I, Cassius Marcellus Clay..." When the assistant suggested Clay change the first line to Cassius M. Clay Sr., Cassius replied, "No! There is but one C.M. Clay—all the rest came after me; I alone have the name, without an affix."[306] Too true, there never has been another man like him.

The man who was larger than life was gone, and his home now stood in lonely vigil. What was to become of Clay's grand estate?

PART III
ABOLITION
This House Lies in Ruins

Is it time for you to live in your paneled houses
while this house lies in ruins?
—Haggai 1:4, God's Word Translation

One could imagine that the morning of October 8, 1903, in northern Madison County, Kentucky, dawned clear and bright with Indian summer warmth. A large group of local and not so local people gathered on the Clay family's palatial estate in the hopes of claiming a piece of the old fiery general's personal effects. It had been part of Clay's will that he wanted his possessions to go up for auction,[307] so perhaps Cassius would have approved of the large crowd and the number of items that went up for public sale, so many in fact that it took two days to auction off all of the pieces.[308] A twenty-four-page typed report of the sale list made by the State Bank & Trust Company (administers of Clay's estate), which recorded each of the items, showed that the grand total for the sale was $3,653.[309]

Clay's most impressive possession, however, was not available for purchase until two weeks later. On October 22, 1903, just a few days after Clay would have turned ninety-three, had he still been living, White Hall was put on the auctioneer's block along with the surrounding land. Some might question why the home was not given through Clay's will to a descendant. Clay left his remaining heirs in quite a tizzy when he died, as he had as many as six wills floating around at his death.[310] Some were very similar to one another, with only minor changes. Others were very drastic in the differences. Dora Richardson Clay Brock wanted her share of the pie and took Cassius's

children to court over the wills, as a few of them were very generous to the former Ms. Richardson,[311] a fact that Clay's children were not happy about. The wills were eventually declared null and void by a judge, with the property to go to Clay's "natural heirs."[312] After many months of lawsuits and court dates, Dora had to concede to the biological children and slink away with nothing more than some wasted time to show for her efforts.[313]

Despite the battle in court over Cassius's estate, White Hall mansion proved to be a large deteriorating structure that none of the children had a desire to obtain or restore. It was a descendant who would acquire ownership of the towering domain. Cassius's grandson, Warfield Bennett Sr. (Sarah Lewis Clay Bennett's son) purchased the mansion and 360 acres of land that surrounded the home for $30,060.[314]

As a young boy, Warfield had visited his grandfather Cassius and took the necessary precautions, lest his grandsire mistake him for a trespasser of the vendetta nature. Crawling on his hands and knees up the last part of the driveway, Warfield would shout, "Don't shoot, grandpa, it's me, Warfield!" Decades later, Warfield's granddaughter, when discussing the relationship her grandfather had with his own grandfather, Ann Bennett commented, "I got the feeling they were fond of each other, which may explain Warfield's love of the old place."[315]

Although a successful bank commissioner,[316] Warfield was a farmer at heart, and he may have purchased the home for sentimental reasons, but the main motivation was more than likely the prime real estate that surrounded the house. Bennett used the land purchased for tobacco cultivation (a very lucrative cash crop at the time), along with other cash crops such as wheat and corn. Bennett also followed in the footsteps of his grandfather Cassius and great-grandfather Green and raised sheep on the property, as well as pigs.[317]

While the land surrounding it was rich and productive, it appeared that the mansion's glory days were over. The building was not in great condition; Cassius had not given his home the tender loving care in his later years (or, being the big money pit it is, the massive continuous upkeep) that it needed. After Warfield purchased the home, he only provided minimal maintenance. The older Clermont section of the first floor and the 1810 addition on the back were used as living quarters for various tenant farmers. The impressive drawing room, once the setting for grand parties and entertainment, became agriculture storage space for hay bales and feed sacks. More hay bales were stored upstairs in the massive bedrooms and hallways.[318] The daunting first-floor reception hallway, which once awed Clay's visitors upon their arrival, now served as a garage for a tractor.[319] Although many guests today,

upon hearing what became of the mansion in these years, express surprise, disbelief and sometimes disdain, it should not be thought of in such a way. Warfield simply used the house any way that he could, and it makes sense, given the large size and the advanced level of deterioration, that the home was used as a barn.

It should not be misconstrued that Warfield Bennett was happy with the way his ancestral home was turning out. In an interview nearly fifty years after his purchase, when asked about the derelict state of the house and surrounding land, he stated, "I can't think of it, can't let myself." In that same interview, he expressed a desire to be younger and more able to oversee the farm's production like he once did.[320]

Ann Bennett, a great-great-granddaughter of Cassius M. Clay and granddaughter to Warfield, described the visits when her grandfather would allow her to walk around the dilapidated old mansion:

> We would get to come out to Whitehall when we visited, if we were lucky. I remember it being quite an adventure, driving the old road, pulling up in front of the enormous house. We would be watched closely and be instructed to be very careful not to fall through the rotten floor boards or touch the crumbling railing on the stairs. We couldn't even think of going upstairs—I think some of the railing had been burned for heat by poachers or transients that had spent some time in the old place. There were wasp nests and bats and lots of trash…There was a sadness about those visits too—the few there were—in that the place was "too far gone" to ever be "saved" my grandfather said. As a child, the whole idea that something grand could just slowly fall down and that would be the end of it, was a lot to grasp. I remember feeling the sadness, but then not thinking too much about it, just accepting it.[321]

Sadness is what many people conveyed when they walked around in the empty, echoing halls. A guest to White Hall once told the author that her father owned a farm behind the Bennett property. He visited White Hall once and came home with tears in his eyes, saying, "Somebody needs to restore that place."[322] Another individual who visited the mansion when abandoned made the comment, "It makes you feel like you're walking on land where you shouldn't be."[323]

The house was not totally empty. Tenants resided in the house from right after the mansion was purchased at auction in 1903 to the mid-1960s. Numerous families lived in the house in the older section of the first floor in the main house, as well as the old kitchen and cook's residence off of the back porch.

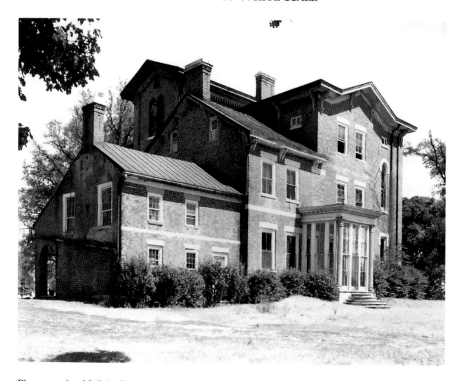

Photograph of White Hall showing the original Clermont side, circa 1940s. Tenants would have resided in this back area. *Courtesy of Kentucky Department of Parks.*

Judy Ballinger King, a former tenant of White Hall, visited with the curator and described her time of residence in the mansion. Judy, her parents and grandfather occupied White Hall in the early 1950s, when Mrs. King was five and six years old. The Ballinger family resided in the former library and pantry of the mansion. There was no electricity; instead, coal oil lamps and a coal stove were used.

Judy was an adventurous little girl:

> *I would get out and roam this house, I'd be gone all day. I wasn't afraid. I would get out and ramble all over the place. I would get lost a lot of times and couldn't find my way back down, that's why I'd stay up there just about all day. The only time that I think that I almost panicked it was getting late in the day and that's when I couldn't find my way back downstairs because I would get lost up here; there was so many rooms.*[324]

The only area in the mansion Judy did not like to visit was the basement. In her words, the area was "cold, damp, dreary and depressing." She recalled the manacles in the jail cell being on two of the walls.

Judy could have quite possibly been White Hall's first docent. She certainly would have been its youngest and sweetest. Visitors would hear about White Hall and drive out to the gate of the property. Judy would volunteer to take them through. After a story ran in a local newspaper, with images and information about White Hall, Bennett put a stop to the impromptu tours.[325]

Although a portion of the great mansion was inhabited, this did not stop trespassers from stopping by and snooping, with or without a tour guide. Life at White Hall was not always a quiet and private venture for the tenants. Thrill-seekers would make unannounced house calls. Some visitors would reverently walk the echoing halls and depart without a trace, while others would leave their names on walls to prove that they had visited.[326] Some would do extensive damage to the site, in one case burning the banister of the grand

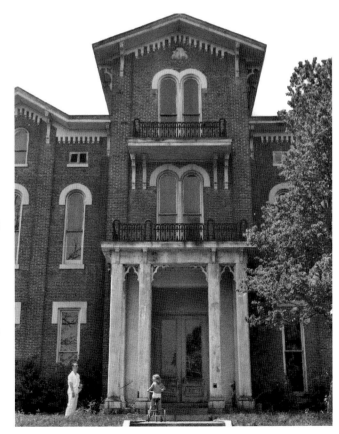

Photograph showing the front porch of White Hall, circa 1951. This photograph was originally published in the May 31, 1951 edition of the *Lexington Leader*. Seen in the photograph are an unidentified person and tenant Judy Ballinger on the tricycle. *Courtesy of Kentucky Department of Parks.*

staircase.[327] Still others would attempt to pilfer a relic. On one such occasion, in the occupancy of the last tenants to reside in the home, uninvited guests stood on the front portico of the mansion attempting to chip away at the brick and marble in order to pocket a token of their visit. When advised by a tenant that they not deface the structure, a gun was pulled on the resident.[328]

Fraternities from the local colleges and universities were also uninvited guests at White Hall and made visits part of their activities. One guest while on tour with the curator mentioned that when he attended school, it was part of the initiation to travel to White Hall and take back to his organization a spindle from the main staircase to prove that he had been "brave" enough to visit the haunted old house.[329] Another guest recounted how she knew of different college organizations that would drive their initiates out to the mansion, drop them off and make them find their own way home. In her words, "Everyone was out there but who should have been out there."[330]

Photograph of the formal reception hall, circa 1950s. The piano seen in this image is surrounded by feed sacks. The instrument is a patented 1859 Steinway and is the only artifact to have resided in the mansion since Cassius M. Clay's death; it has never left the building. Supposedly, when restoration took place, a family of chickens had been roosting inside of it. *Courtesy of Kentucky Department of Parks.*

Sometime in 1965, the last tenants moved out of the mansion, leaving the huge house to deal with the elements and vandals on its own. The house was suffering a slow and agonizing death. The home, like the great man who once lived there, was fading from history.

Yet it would seem that some people had not forgotten White Hall. In 1965, the Richmond Garden Club began a crusade to get others in the community involved with the restoration of the deteriorating mansion. On one visit to the decaying manor, one club member, Betty Cox, cajoled her husband into visiting the site with her. Since her husband, James, was a professional photographer, she persuaded him to take pictures of the estate. This he did with an eye of an artist, focusing not only on the heartbreaking destruction that had occurred but also the beautiful architectural details that still survived.

Mr. Cox had heard stories about Cassius M. Clay since he was a boy. One of his first experiences involving Clay was studying the man while in the sixth grade. Excited about the stories concerning Cassius and his involvement with freeing the slaves, Cox went home to relay the tales to

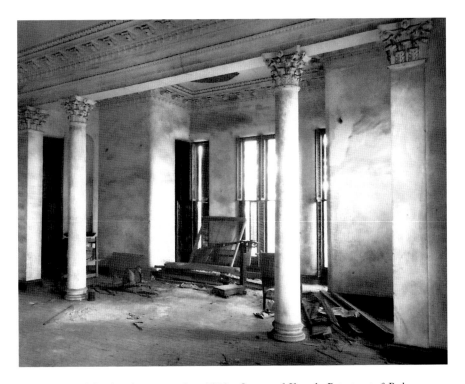

Photograph of the drawing room, circa 1950s. *Courtesy of Kentucky Department of Parks.*

Photograph of the library, circa 1965. The mantel in this room is one of three surviving mantels in the mansion. Notice the wallpaper that had been placed over the glass bookshelves and the stovepipe hole in the wall, both remnants of when tenants resided in this room. *Courtesy of James M. Cox.*

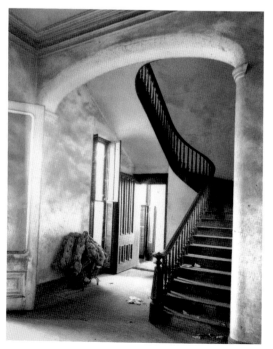

Photograph of the grand staircase in the formal reception hall, circa 1950s. Vandals would later destroy the banister, newel post and spindles. Notice the canvas tarp stored beside the stairs. *Courtesy of Kentucky Department of Parks.*

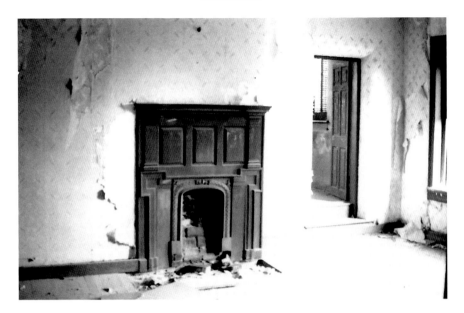

Photograph of the master bedroom, circa 1965. The mantel in this room was one of three to survive. Notice the wallpaper on the walls. This is believed by the authors to be original wallpaper to the mansion. Unfortunately, it was not saved. *Courtesy of James M. Cox.*

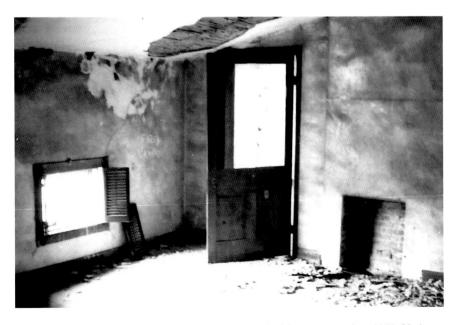

Photograph of a third-floor bedroom, now known as the history room, circa 1965. Notice the ceiling is in terrible condition, and the fireplace mantel has been ripped out. *Courtesy of James M. Cox.*

his mother. His mom replied with, "We don't talk about him; he wasn't a good man."[331] Many of the older generations who could remember Cassius or had heard stories from their parents or grandparents had very jaded opinions of the man. Despite a less than positive reputation, there were those who still admired Cassius. Perhaps it was evoked admiration that inspired Mrs. Betty Cox and her husband to become concerned about White Hall and its downfall.

The Coxes would visit White Hall frequently and would notice how pieces were gradually being taken out of the mansion. Mr. Cox remembered viewing the original lining in the bathtub. He recalled, "Then later we came out, like another month, and someone had stolen it, ripped it out." Door hinges and locks suffered the same fate. Another visit found Cox attempting to enter the basement, which was so full of trash that he could not go in from the outside area but instead had to proceed through another entrance. Mr. Cox stated that he feared that the house was in danger of burning down. [332]

Since a picture truly is worth a thousand words, the authors will not continue discussing the downfall of the mansion but rather will allow the readers to examine the damage for themselves in the images in this chapter.

As clearly shown by photographic evidence, the mansion was in dire need of restoration, promptly, before more was lost to the ages. Help was on the way.

PART IV

RESTORATION

From the Ruins I Will Rebuild It and Restore Its Former Glory

In that day I will restore the fallen house of David. I will repair its damaged walls. From the ruins I will rebuild it and restore its former glory.
—Amos 9:11, New Living Translation

W hen the great pass from flesh and blood into history, we often forget that there once were very human souls behind the heroic veneer that time and distance have built."[333] Such was the case with Cassius M. Clay and his illustrious White Hall. The humanity and life would soon be returned to this great man and his house through the efforts and cooperation of many dedicated organizations and individuals.

As previously mentioned, the Richmond Garden Club worked hard to focus attention on White Hall so that restoration could take place. According to Mrs. Helen Chenault, who was president of the club at the time, a number of the members had attended a tea in Louisville on October 5, 1965. On the return trip from the event, the ladies made a stop in Frankfort to speak with the Kentucky Historical Society. The director of the society, Colonel George Chin, was very reassuring and encouraged them to proceed with their efforts.[334]

In order to get the general public to notice the mansion, and perhaps contribute donations and enthusiasm for restoration, the Richmond Garden Club hosted a flower show that 1,500 people attended. The ladies used their expertise in arranging flowers to symbolize and highlight the beauty of the arrangements as opposed to the destruction of the site. They included whatever they found on the premises in their designs; one lady incorporated a hornet's nest she had found at White Hall into her display.[335]

The club also met with numerous directors of historic sites, as well as various organizations such as the Civil War Round Table, in order to gain insight into what was needed and to build up interest.[336] At one point, members enlisted the assistance of the head architect from Colonial Williamsburg, Walter Maycromer. This knowledgeable gentleman arrived one day and perused the mansion and grounds with the ladies. When touring the mansion, Maycromer was enamored of the mantel in the library and commented that it was "the finest example he had seen."[337] He scraped paint off of the wall in the original parlor until he reached a layer of blue paint tinged with green. Mr. Maycromer was positive that this was the original coloring of the paneling. Outside the mansion, Maycomer took a staff and penetrated the soil around the buildings to determine where original walkways would have been located. He made his way down to the stone building behind the mansion and examined it. He was sure that the ten-foot opening to the fireplace was the largest still in existence.[338] The Williamsburg representative was very encouraging and would have gone on to further assist in the restoration process had he not passed away a few weeks later.[339] Although this would be a disappointing turn of events, in the end the club's aid would come from a more powerful source.

William H. Townsend was a lawyer by profession and a historian by interest. He had read a little about the fiery Cassius M. Clay and thought that Clay was the perfect subject for a Civil War Round Table speech he was to deliver to an audience up in the Windy City. In 1952, Townsend gave his oration, entitled "The Lion of White Hall." In this lecture, Townsend colorfully presented Cassius's life in an entertaining way. His talk was so well received that it was recorded and sold to the public. Although the speech did breathe new life back into the history of Clay and got numerous people interested in this great man, it should be noted that the speech is chock full of inaccuracies. Townsend himself once stated that he "never let the truth get in the way of a good story."

In an effort to present Cassius M. Clay as a larger-than-life narrative, he added in information that was not entirely correct. In reality, the true stories surrounding Clay are more interesting than and just as fantastic as anything that can be made up about the man. Even to this day, guests will visit White Hall simply because they have either read or heard Townsend's speech and will want to know more about Clay. When looking back over the influence this oration has had regarding its ability to capture the public's interest, respect and gratitude should go to William H. Townsend for igniting the fire, so to speak, about this historical figure. However, it is the opinion of the

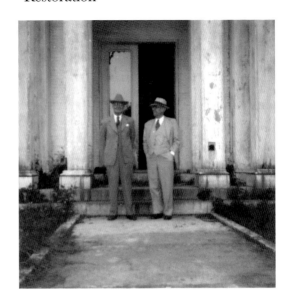

Photograph of Warfield Bennett and William H. Townsend standing in front of White Hall, circa early 1950s. *Courtesy of Kentucky Department of Parks.*

authors that perhaps Townsend shouldn't have tried to gild a lily that was already pretty brilliant to begin with.

Townsend's speech was one listened to often by an attorney named Louie B. Nunn. His daughter, Jennie Lou Nunn Penn, recalled her father reclining in the family's library at their home in Glasgow, Kentucky, listening to a recording of "The Lion of White Hall." Years later, when Mr. Nunn was elected governor of Kentucky, he and his wife drove to Madison County to find Clay's mansion. Penn stated, "I must say that although Daddy had to talk Mother into going with him, it was Mother who came back so excited and determined not to let Kentucky lose this piece of its history."[340]

Through the very public effort of the Richmond Garden Club, Governor Edward Breathitt was made aware of the historic structure. Interestingly, a report prepared by Thomas R. Martinson of the Kentucky Heritage Commission dated September 3, 1967, lists White Hall as being the property of the Commonwealth of Kentucky. Mention is made in this account of the Kentucky Department of Parks surrounding White Hall with a chain link fence and boarding up all of the openings.[341] Breathitt did secure the funds so that the Historic American Building Survey could record the mansion in August 1967.[342] In addition, the Kentucky Department of Parks had already worked on repairing the leaky roof so that further damage would not take place to the interior.[343] Clearly, progress was already underway for White Hall to become a state-owned site under Breathitt's administration. However, although it was this elected official who initially set up an arrangement with

the Bennett family to purchase a portion of Clay's original estate, ultimately it was Governor Louie B. Nunn who signed the deed.

On July 5, 1968, for the sum of $18,375, 13.64 acres of land were transferred from Warfield C. Bennett; Warfield's wife, Ann C. Bennett; and Warfield's sister, Esther Bennett, to the Commonwealth of Kentucky. Along with the transfer of land, it was stipulated that the State of Kentucky would create an entrance to White Hall from the old Fox Town Road and provide fencing on either side of the road from the farmland it would go through. Although the Clay Family Cemetery was not included within the 13.6 acres purchased, the Commonwealth was also required to fence in the burial ground, restore the gravestones within the cemetery and be in charge of the upkeep of that area.[344]

Once the land and home became the property of the state, a massive fence replaced the chain link one in order to keep trespassers away. Guards were posted by day when no workers were present, and night watchmen patrolled the property at night. Governor Nunn put the restoration and decorating efforts into the capable hands of his wife, Mrs. Beula Nunn.

The structure of the mansion was sound, and aside from installing a new roof, repairing the collapsing wall on the west side of the warming kitchen and repointing mortar in the brickwork, no major work was needed.

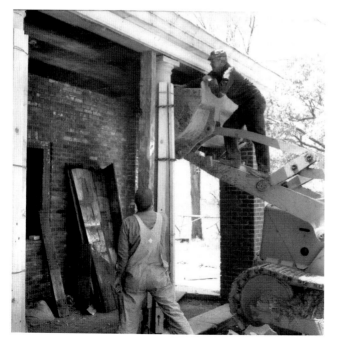

Photograph of workers restoring the columns on the back porch of White Hall. Notice the dirt porch area. This would later be filled in with hexagonal-shaped bricks original to the property. *Courtesy of Kentucky Department of Parks.*

Restoration

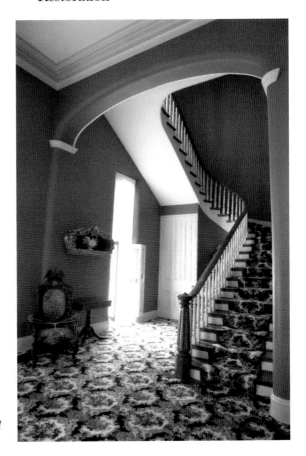

Photograph of the grand staircase in 2012. *Courtesy of Kentucky Department of Parks and Liz Thomas Photography.*

Much of the woodwork in the mansion, particularly on the first floor, was still intact and showed off the natural beauty. However, for some reason not clearly known to the authors, all the woodwork was painted in the house. Perhaps, given the time, it was felt that painted wood was more attractive, and aesthetics took precedence over authenticity. Another reason could have been that the restorers felt that the woodwork should match, and it did not. To give uniformity, perhaps, it was then decided to paint the wood. The original main staircase banister, newel post and railings had been carted off or burned, and a replica based on photographic evidence was rebuilt. The spindles and decorative touches were painted a cream color, although pictures from before the staircase was destroyed clearly show the natural wood.

The original fireplace in the parlor of Clermont, which later became the dining room, had marble around the opening, and there was a "wedge-shaped

99

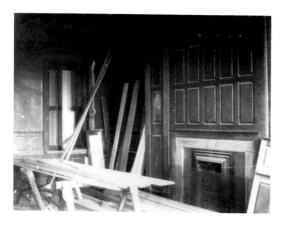

Photograph of the dining room, circa late 1960s. Work is underway for restoration, as evidenced by the sawhorse and wood boards. Notice the original mantel, which would later be covered by another mantel. *Courtesy of Kentucky Department of Parks.*

keystone centered on the lintel."[345] This alone was beautiful and would have been impressive. However, a Federal-style mantel was brought in and made to fit over the opening.

Amazingly, the majority of the flooring (made up of a mixture of yellow poplar and pine) in the mansion is still original today. The only floors to not have survived (both collapsed before restoration could start) were an upstairs bedroom floor and the flooring to the 1810 warming kitchen. These were replaced with old wood and brick, respectively.

Restorers followed the Clay family's original decorating color scheme by painting all of the mansion walls a bright creamy white color. In a second-floor bedroom, Cassius had slammed the original metal plates to his *Memoirs* against the wall and had written beside the imprints his intention of publishing another version of his work. According to one account, Clay's handwriting was "amazingly clear and legible."[346] There was the intention of framing this area off so that guests would be able to view it on tour. However, the painters got to it before the framers did.[347] Thus a window into the history of Cassius and his house was lost. The Clay family had also originally wallpapered a number of the rooms in the house, and this was taken into consideration, although none of the paper was preserved. What walls weren't left the white shade were papered in historic reproduction wallpaper.

Looters long ago had ripped away the original metal to the bathtub. The state replaced it with a copper lining.[348] Likewise, the original woodwork to the wastewater disposal room had been torn away, either by looters or by state restorers. A porcelain sink was put in the place of the original wooden structure, and thus began the onset of forty years of misperception and misinterpretation on the usage of the room. The toilet room was cleaned out, and an earth closet was placed where the original flushing toilet would have been. This was an inaccurate representation of what the Clay family

Restoration

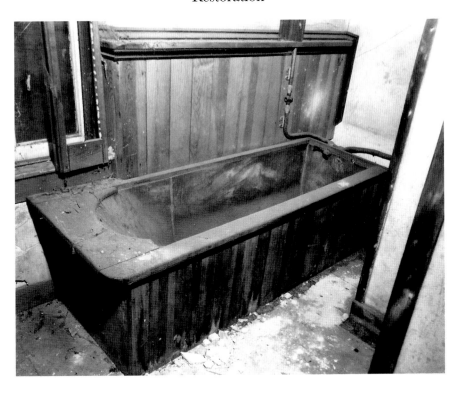

Above: Photograph of the bathtub with original zinc lining, circa 1950s. Notice the structure juts out from the wall to make room for the piping. *Courtesy of Kentucky Department of Parks.*

Right: Photograph of the original pipes leading down from the water storage tank to the bathtub, circa 1950s. Notice the shower above the bathtub. *Courtesy of Kentucky Department of Parks.*

Photograph of the copper-lined bathtub in 2012. Notice the structure is fitted flush against the wall. *Courtesy of Kentucky Department of Parks and Liz Thomas Photography.*

would have had, but it was correct to the time period in which the Clay family lived.

The water storage tank on the third floor had the lining refurbished, three drains were added in to show where the water would have drained out[349] and glass plates were installed over top of the cistern so that guests could view inside the reservoir. A railing was added around the storage tank for safety.

The basement proved to be an area that probably could have used a HazMat team. Decades of trash had filled the area to the brim. The original furnace was mistaken for garbage and carted out with the massive amounts of trash from the basement.[350] The original ceilings were lowered somewhat with the installation of electrical lights, and the original dirt floor was covered with brick.

Master carpenter Floyd Nuckols oversaw the structural restoration. Nuckols had great appreciation for the work his predecessors Lewinski and McMurtry had accomplished in their construction of the mansion, and he stated that "restoring White Hall was like reassembling a fine piece of art."[351]

A restored home is impressive to behold, but an empty mansion is not quite as striking as a furnished one. Once the mansion was complete,

Aboeve left: Photograph of the wastewater disposal room, circa 1954. *Courtesy of Kentucky Department of Parks.*

Above right: Photograph of the wastewater disposal room, 2012. The original wooden structure was replaced by a porcelain sink. *Courtesy of Kentucky Department of Parks and Liz Thomas Photography.*

Right: Photograph of the toilet room, circa 1950s. Notice the original piping and wooden base for the toilet. The wooden piece with the circular cutout is the top of the structure from the wastewater disposal room. *Courtesy of Kentucky Department of Parks.*

Above left: Photograph of the toilet room in 2012, shown with an earth closet. Notice that the piping that originally was exposed is now covered by wall. *Courtesy of Kentucky Department of Parks and Liz Thomas Photography.*

Above right: Photograph of the water storage tank on the third floor, circa 1950s. *Courtesy of Kentucky Department of Parks.*

Right: Photograph of the water storage tank in 2012. *Courtesy of Kentucky Department of Parks and Liz Thomas Photography.*

Photograph of the basement, circa 1965. Notice the finished ceilings. *Courtesy of James M. Cox.*

it then became Mrs. Beula Nunn's mission to fill the home with historic pieces. She hired a team to track down Clay family descendants who may have inherited a portion of the Clay estate. She also had these individuals study the original 1903 auction list and search for the descendants of the purchasers. Amazingly, contacts were made, and individuals were generous enough to donate artifacts to the state.[352] Mrs. Nunn was so successful that she was able to furnish White Hall almost entirely from donations and from her findings in Kentucky State's surplus

Photograph of the basement in 2012. *Courtesy of Kentucky Department of Parks and Liz Thomas Photography.*

storerooms. According to one account, the only purchase of furniture made by Nunn was a bedroom suite of rosewood, which Beula stated "was early Kentucky and there was no other way I could talk the woman out of it."[353]

Mrs. Nunn had knowledge of and an eye for interesting pieces, and if those pieces had Clay connections, so much the better. If an owner did not readily donate or sell the coveted piece, then she had other ways of acquiring the artifact. Being the state's first lady didn't hurt. One such item that Mrs. Nunn ran across and became determined to obtain by any means necessary was a bust of Cassius M. Clay. Joel Tanner Hart was born in Winchester, Kentucky, but was classically trained in the art of sculpture. His first subject was Cassius.[354] After Cassius's death, Clay descendants donated the bust to the University of Kentucky (UK), where it resided in Special Collections and Archives. When Nunn was informed of the location of said bust, she just had to have it. She wasted no time in getting assistance from another Clay, Albert Clay (not known if he was actually related to the Clays discussed in this book), who at the time was the vice-chairman of the UK board of trustees,

Photograph of the elusive bust of Cassius M. Clay sculpted by Joel T. Hart. Notice that the docent is very proud that the artwork is in the mansion. *Courtesy of James M. Cox.*

and convinced the man to open up some doors for her on campus. Nunn planned a heist that would have put a professional jewel thief to shame.

Nunn executed her plan with success, and she proudly displayed the bust in White Hall. The University of Kentucky was informed of the location of its absent artwork and allowed the bust to remain at the historic site until the Nunns left public office as the first family. The sculpture was then transported back to the university, never to again see the light of day outside Special Collections' walls. Years later, in an effort to showcase the piece at a Clay family reunion, the curator made multiple attempts to have a loan made between the two institutions. However, UK was not willing to part with the bust for even a short period of time. Perhaps the university felt that possession is indeed nine-tenths of the law.

Despite the exodus of that particular artifact, other items with Clay connections made their way back to the old homestead and have resided there ever since. Some artifacts were donated during the restoration of the mansion; others were given years later. White Hall has numerous antique items that are warranted by their beauty and history alone; however, staff members are especially proud of a number of items that have clear Clay family connections. These pieces are worthy of merit not only on their own but also in that they help strengthen the Clay family's legacy in a tangible way.

Probably one of the earliest family pieces on display is an American eagle pommel sword, circa 1808, believed to have been used by General Green Clay when he served in the War of 1812. As briefly discussed in the first chapter, General Green Clay's military career was very imposing. Clay served in the Revolutionary War. Arguably, his most impressive service was as a brigadier general in the War of 1812. Green Clay was one of numerous Kentuckians who united around his country's flag, and in May 1813, Green led three thousand volunteers in the relief of Fort Meigs in northern Ohio.

General Harrison was in command at the time and was surrounded by British and Indian armies. Green cut his way through the enemy lines, and the British troops were forced to give way to him and his militia. General Harrison left General Clay in command of Fort Meigs. Later in the autumn of that same year, the fort was invaded a second time, by General Proctor and 1,500 British troops, as well as Tecumseh and 5,000 Native Americans. However, these opposing troops were unsuccessful and, in the end, were forced to retreat. In an inventory of General Green Clay's possessions from Fort Meigs, there is a sword listed in with his personal belongings. This is believed to be the sword in White Hall's collection.

The sword had been handed down from generation to generation of Clay family members and eventually was put up for auction. It was then purchased by a private collector. The collector maintained the sword for several years. In 2007, the Kentucky State Park Foundation purchased the sword for display at White Hall.

Another fine piece of weaponry that belonged to a Clay is Cassius M. Clay's cannon. Since Cassius's time, stories have abounded regarding Clay and his infamous pair of cannons. Interestingly, in all of the stories that the authors have been able to clearly document, the cannons were never actually fired but rather were simply used for intimidation purposes. Unfortunately, the White Hall staff was previously only able to recount (and debunk) stories of the artillery and their usage with just a photograph to prove of their existence.

This all changed in 2003 when one of the weapons was generously donated back to the site by a Clay family descendant. A reference made in a newspaper article stated that the other cannon had been donated to the Tennessee Historical Society,[355] which prompted the curator to call the organization and inquire about said piece. Sadly, the spokesman for the society claimed to not know anything about the artifact (probably as he stroked the big gun on his office desk a la evil genius Ernst Stavro Blofeld, stroking his white cat in a James Bond film).

Photograph of Cassius M. Clay's cannon. *Courtesy of Kentucky Department of Parks and Liz Thomas Photography.*

It's not all about the boy toys, though. White Hall has many fine pieces of furniture; two artifacts that were very personal to Cassius M. Clay are his gout stool and his Wooton desk. As previously mentioned, Cassius developed gout, a type of arthritis that affects the joints, most of the time in an individual's legs and feet, which makes walking very difficult and painful for the afflicted. The condition is caused by uric acid, a waste product made by the body. Normally, uric acid is flushed out of the body through the kidneys and urine. When an individual has too much of this waste product, the acid produces crystals that typically become deposited in the joints. Such deposits cause inflammation, resulting in swelling, tenderness and pain in the affected area.

Clay's gout stool is designed so that it can be moved in two different directions in height and angle, hopefully relieving the leg and foot pain of the afflicted limb. A former curator once commented that this was a favorite piece of furniture of hers because "[t]o me this is a very personal piece of furniture that is indicative of his failing health and the human weakness endured by Cassius."[356] Clay was in good company with other historic individuals afflicted with gout, including Samuel Johnson, Benjamin Franklin, Thomas Jefferson and John Milton, who died as a result of complications from the condition. Milton reportedly told a friend that if he did not have gout pain, his blindness would have been bearable.[357] It may have seemed that Cassius was invincible, but in reality, he was human just like the rest of us.

Whereas the gout stool is a small, unassuming piece of furniture, the Wooton desk inspires in guests awe and an obsessive-compulsive desire to organize their home or office once they leave White Hall. For those who liked orderliness, the Wooton patent office secretary desk was ideal. Originally created by William S. Wooton in 1874 in Indianapolis, Indiana, this desk was produced at a time when one man could manage a business with one large desk in which all of his records could be filed. The desk's heyday was in the 1870s, when the industrial revolution caused an increase in business activity, and more desk and file capacity was required. Sadly, by the 1890s, the Wooton had become outdated, as typewriters and duplicating machines made smaller desks more popular. The Wooton desk today stands as a testament of form following function. The desk was immensely useful in its prime and still today stands as a beautiful piece of American history. Wooton patent cabinet office secretary desks came in four different grades: ordinary, standard, extra grade and superior grade. White Hall has a standard grade desk, which Cassius M. Clay originally owned and then passed on to his son Brutus Clay. Perhaps he even used it when he wrote his *Memoirs*.

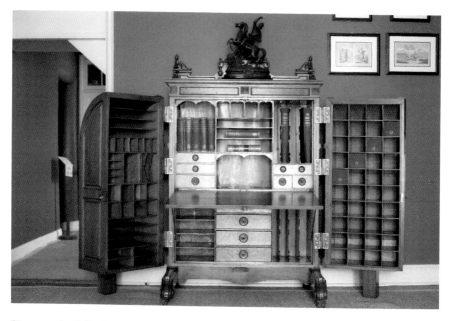

Photograph of Cassius M. Clay's Wooton patent office secretary desk. *Courtesy of Kentucky Department of Parks and Liz Thomas Photography.*

In his seventies, Cassius M. Clay chose to pen his *Memoirs* in an effort to memorialize his actions regarding antislavery and politics. *The Life Memoirs, Writings and Speeches of Cassius M. Clay*, vol. 1, was a six-hundred-page memoir that spanned Clay's life up to the mid-1880s. In addition to covering the politics that Clay was involved with, topics within the book are varied and range from Clay's favorite authors to his defense of an African American foreman against the Ku Klux Klan. As the name implies, the work also contains a great deal of Clay's writings and speeches, as well as various letters.

Clay's *Memoirs*, when originally published, were sold by subscription only. Buyers could choose from four different styles ranging in price from five to ten dollars. Although the subscription was to be for two volumes, only one was ever published.[358] Few original copies of the *Memoirs* still exist today. In 1968, a reprinting of the *Memoirs* that included a reference index was produced in Berea, Kentucky, and coincided with the opening of White Hall State Historic Site. In addition, Negro University Press did a reprinting in 1969, though without an index. Today, reprinted copies can be purchased online; one can even search the inside of the book via Google Books.

In speaking of his *Memoirs*, Cassius stated, "Henry Wilson seems to think that the emancipation proclamations are the great events, not only of the

war, but of the age. They are. But he also seems to be quite in the mist as to the causes and movements in that regard. To show my connection with these great events, and to throw light on their causes and effects, is one of the most potent motives for my writing these Memoirs."[359] Cassius M. Clay was a man who aspired to greatness, certainly with his ideals concerning freedom, and it is regrettable that he is often overlooked in the pages of history. Oftentimes, the legends surrounding the man take precedence over the facts. It is therefore heartening that a work exists to prove that Clay was, in his own words, "*Quorum pars fui*" ("Of them I was a part").

There are sections of the *Memoirs* in which Cassius does not speak well of his first wife, Mary Jane. Because of this, his children tried their best to eradicate the publication but were unsuccessful. Few original copies exist today, but there are still a few floating around, and occasionally the tides of chance wash a copy back to the shore of White Hall.

While some artifacts, such as the *Memoirs*, are able to tell all, others give silent testimony. The expression "If these walls could talk…" has been used often. Certainly, such could be said about White Hall. This expression can also be used when referring to Mary Jane Warfield Clay's royal Russian presentation dress. When Cassius M. Clay was appointed minister to Russia in 1861, Mary Jane Warfield Clay and five of their children traveled to Russia with him. It was customary at the time for the foreign ministers and their spouses to be presented to the imperial Russian court. Attire for such an occasion must be perfect. In an October 28, 1862 letter addressed to her sister, Julia, Mary Jane discussed her search for the ideal dress: "I went out this week in search of a court dress…A ball dress is the dress…I selected an [*sic*] gold silk covered with white velvet figures a goods somewhat resembling my old rose colored velvet of Grandmamma Barr's…I will hand it down to my grandchildren as Grandmamma's descended to me…I bought a headdress of feathers and gold cords and tassels to wear with it."[360]

Just as Mary Jane had envisioned, the lovely gold presentation gown went on to be worn by her descendants. Mary Jane's eldest daughter, Mary Barr Clay Herrick, visited her uncle Brutus in Washington in 1864 and, while there, wrote back to her mother, "Last night we went to Mrs. Lincoln and Pres. Lincoln's. The house was crowded and all kinds of dressings. I wore your yellow silk…and had many compliments paid."[361] Nearly twenty years later, Mary Jane's youngest daughter, Anne Clay Crenshaw, had a studio portrait made of herself in the dress refashioned in a contemporary style. Mrs. H. Hersee Bullock Jr. (aka Mary Barr Clay Bullock), a great-granddaughter of Mary Jane's, wore the dress, redesigned a third time, at a "Lincoln tea" given

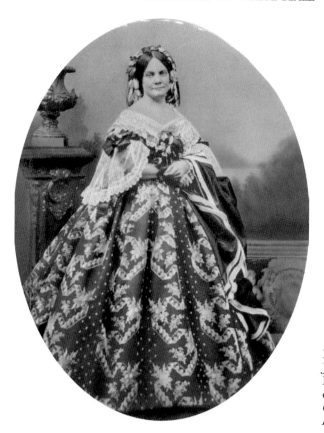

Photograph of Mary Jane Warfield in her Russian presentation dress, circa 1862. *Courtesy of Kentucky Department of Parks.*

by the Historic Memorials Society in the late 1920s or early 1930s.[362] Later, at an unknown point, the dress was altered a fourth and final time, and this is how the dress appears today. This dress witnessed the royal Russian court in its prime, it encountered what could be arguably called the greatest president of the United States and it was passed down through at least four generations of Clay family women. The dress eventually was donated to the J.T. Doris exhibit at Eastern Kentucky University and is on loan to and currently on display at White Hall State Historic Site.

These are, of course, only a few examples of all the amazing items that came to be on display in the mansion. Furnishings and decorative pieces arrived from descendants, as well as local people who had an interest in helping furnish the mansion. In addition, items were purchased from antique businesses, as well as from collections already owned by the State of Kentucky. Even bartering took place, as Beula Nunn traded with a local house museum, giving it a painting in exchange for Clay's dueling pistols.[363]

The mansion was not the only building to be restored. There were seven additional original structures still standing when the state took control of the property. The icehouse, located behind the mansion, had the trash cleaned out of the deep circular structure and a new roof built over top of it. The henhouse had new siding and a new roof built on, and it retained its original white color. The old mule barn located in front of the mansion was kept in the same location but was reoriented at a ninety-degree angle. The walls and roof were reconstructed and doors added. A brick sidewalk was added around the building. From the opening of White Hall in 1971 to 2009, this building was used as a gift shop for the park. The gristmill beside the mule barn also sported a new roof and reinforced sides. The interior of this building was gutted so that restrooms could be installed for the public. A wooden and stone building located beside the gristmill, which could have been originally used as a tack shop or storage site for lumber or grain, was cleaned up and repaired as well. Two other original buildings, the stone kitchen/loom house and the smokehouse, were restored at a later time.

Trees and other plantings were incorporated into a landscape design for the park. The Richmond Garden Club continued supporting the mansion by installing a flower garden into a circular brick-lined flowerbed that faced the conservatory.

To make access easier from the interstate, the highway department paved a road from US 25 to the mansion.[364] A parking lot was also paved on the park, as well as a circular drive leading up to the great house.[365]

When Louie B. Nunn became governor, his wife was asked what she would do in Frankfort. "Just mend the roof on the Capitol,"[366] Beula Nunn replied. Mrs. Nunn did that and additionally restored the State Reception Room in that building and redesigned the Governor's Mansion. The Nunns helped to establish the Kentucky Mansions Preservation Foundation.[367] This would serve as a repository for the Governor's Mansion, White Hall and, later, the Mary Todd Lincoln House in Lexington, Kentucky—she led a campaign for the acquisition and restoration of the latter site.[368] It is the authors' biased belief, however, that her greatest accomplishment was the enormous amount of enthusiasm and arduous labor of love that she put into White Hall. In speaking of her work on White Hall, Circuit Judge James Chenault once said, "She has spent countless hours here. If there was a spot on the floor, she would get down on her hands and knees and fix it herself. She even moved a trailer to the grounds and often stayed overnight. The governor lost a wife but White Hall gained a caretaker."[369] Certainly this great lady had drive and ambition, and she accomplished much in a mere four years.

Photograph of First Lady Beula Nunn and William Bennett in front of White Hall, circa 1964. William Bennett is a great-great-grandson of Cassius M. Clay. *Courtesy of Kentucky Department of Parks.*

Originally, the plan was for the restoration to take place over a period of six years.[370] However, as the Nunns' administration came to a close, the work was sped up so that the opening could still be held within their reign. Although the state tried to keep costs down by using inmates from the LaGrange and Eddyville Prisons to do a large portion of the work—such as duplicating woodwork, doors and shutters in the mansion and refinishing furniture,[371] the restoration ended up costing the state $124,000. Of this amount, $24,000 came from the Parks Department, while the lion's share (pun intended) of $100,000 was ponied up by capital funds.[372] The end result of the park and mansion, however, is priceless.

Through years of hard work, the mansion was once again beautifully furnished and was indeed a showplace. If you build it (and repair, wallpaper, paint and furnish it), he (and she and they) will come. Now let's take a look at White Hall and how the site has changed over the last forty years or more of public service.

WHITE HALL STATE HISTORIC SITE

Greater than the Glory of the Former House

The glory of this present house will be greater than the glory of the former house, says the Lord Almighty. And in this place I will grant peace, declares the Lord Almighty.
—*Haggai 2:9, New International Version*

September 16, 1971, was a perfect late summer day. Governor and First Lady Nunn declared that date "Madison County Day" and invited all of the residents of that region to attend a 2:00 p.m. ceremony that would mark the official opening of White Hall, a Kentucky State Shrine.[373] The inaugural celebration was met with a very enthusiastic crowd. Photographs from the day show a multitude of people grouped together on the park grounds or crowded into the rooms of the mansion.

Circuit Judge James S. Chenault served as master of ceremonies on that momentous day and welcomed the guests under a grove of trees. Many individuals and organizations were honored, including the Richmond Garden Club, the Madison County Historical Society, First Lady Beula Nunn (who was considered a guest of honor on that day) and various Kentucky State employees, to name a few.[374] Governor Louie B. Nunn addressed the crowd of some 1,500 attendees. In reference to the extensive work that had taken place at White Hall, Nunn stated, "By repairing, by restoring White Hall to its original splendor, our goal is to resurrect more than just a home. Our hope is that we shall have helped to restore the magnificent spirit born here, a spirit which never really died but still touches the lives of free men everywhere."[375] Governor Nunn also spoke

Photograph of opening day, September 16, 1971. Guests gather in the brick-lined flower garden that had been restored and landscaped by the Richmond Garden Club. *Courtesy of Kentucky Department of Parks.*

about Cassius M. Clay, claiming, "He lived his years in such a manner that the course of history was forever altered. His shadow extended beyond his own time into our time and by preserving this, his home, we will insure that his shadow will extend into the future."[376]

At its opening, the park had the slightly exalted title of White Hall State Shrine. This name continued on until the mid-1980s,[377] when White Hall State Historic Site became the moniker, although the locals still insist it's "The Shrine."

Though the park would open with a restored mansion, grounds and several outbuildings, two other structures would be repaired at a later date. The smokehouse was toured on opening day as a skeletal building, with only the four corners and roof in place; the walls and foundational portions of the structure were later added back.

The stone kitchen and loom house slowly deteriorated for two more decades before restoration began on the building. The building's history

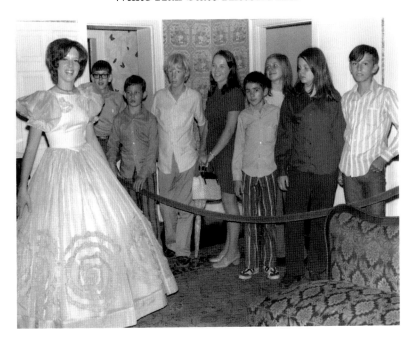

Photograph of opening day, September 16, 1971. A beaming docent shows the master bedroom to a crowd of young guests. *Courtesy of Kentucky Department of Parks.*

Photograph of opening day, September 16, 1971. A large crowd gathers under the Kentucky coffee bean tree to listen to speakers. The tree was considered the largest in Kentucky before it succumbed to the elements and was removed in 1993. *Courtesy of James M. Cox.*

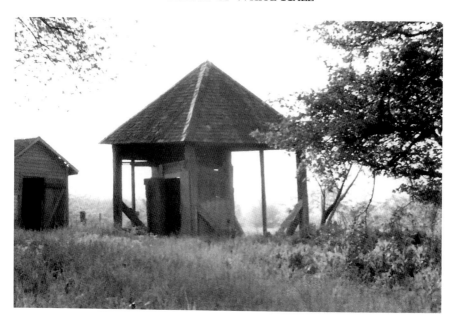

Photograph of the smokehouse and chicken house before restoration, circa 1965. On opening day in 1971, these buildings would appear very similar to this, but they were later restored. *Courtesy of James M. Cox.*

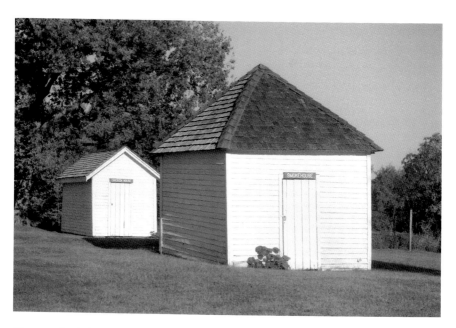

Photograph of the smokehouse and chicken house in 2012. *Courtesy of Kentucky Department of Parks and Liz Thomas Photography.*

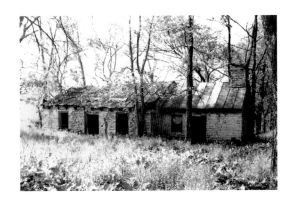

Right: Photograph of the stone kitchen and loom house, circa 1965. *Courtesy of James M. Cox.*

Below: Photograph of the stone kitchen and loom house in 2012. *Courtesy of Kentucky Department of Parks and Liz Thomas Photography.*

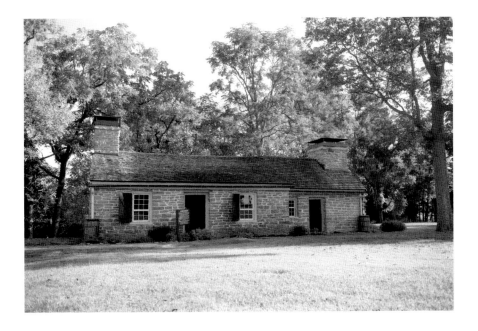

was heavily researched, and very few changes to the original structure were made. The outside wall stonework was removed but numbered, so that it was placed back in its original location. New flooring and wooden supports over the massive fireplaces were installed; however, the support beams in both buildings and the wooden walls in the loom house remain the original. The end result was a structure that Green Clay would have recognized as his own had he returned from the grave. This building was opened to the public for the first time in 1995, complete with an interpreter who would bake biscuits on the hearth just like slaves would have been done in the late 1700s, when

the building was first erected. This interpretation continued for a little more than a decade when, due to lack of staffing and funds, the building became a self-interpreted part of the park.

Research is still being conducted concerning the usage and placement of other original buildings on the property. Whenever a heavy drought occurs, the outlines of the old buildings and the original carriage path slowly start surfacing on the grounds. It is like seeing the ghosts of these former buildings appear. In the summer of 2012, archaeological work began on the park to discover some of the secrets that the terrain holds. Who knows what fascinating information will be discovered as the work progresses.

In 1998 and 1999, the mansion received a modern makeover in the form of an updated heating system with an air-conditioning addition. For those employees and guests who endured the mansion on a hot summer's day, this latest innovation was most appreciated, as temperatures could reach over one hundred degrees on the top floor in the summer months. The heat certainly gave guests a more authentic experience for how the Clay family would have lived. The air conditioning was not just for the comfort of guests and staff but was also employed to control the changing humidity and better preserve the priceless artifacts contained within the mansion. In a nod to the original

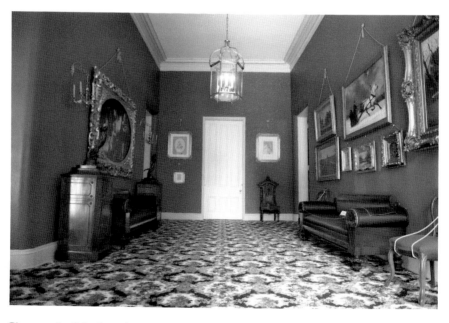

Photograph of the formal reception hall in 2012. *Courtesy of Kentucky Department of Parks and Liz Thomas Photography.*

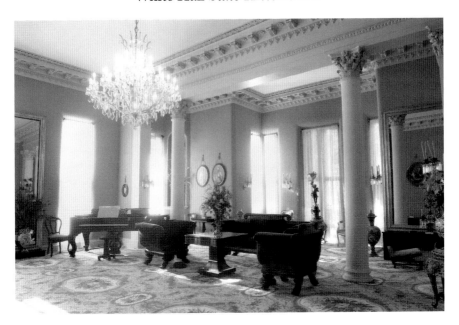

Photograph of the drawing room in 2012. *Courtesy of Kentucky Department of Parks and Liz Thomas Photography.*

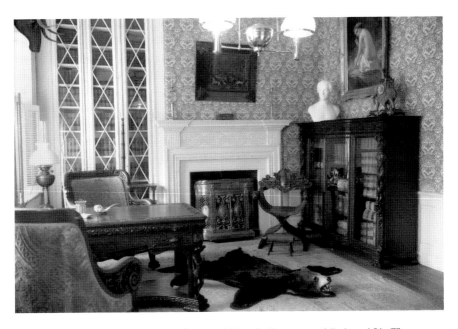

Photograph of the library in 2012. *Courtesy of Kentucky Department of Parks and Liz Thomas Photography.*

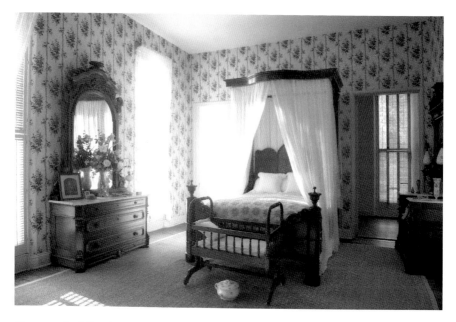

Photograph of Sarah's room in 2012. *Courtesy of Kentucky Department of Parks and Liz Thomas Photography.*

heating system installed in Cassius and Mary Jane's time, the workmen used the innovative ductwork from the original heating system to run the wiring through the mansion for the modern heating. Reproduction armoires were installed in various rooms of the mansion to tuck the massive HVAC units inside. In addition the mansion also received freshly painted walls in shades of cream, green and burgundy and a new copper roof. Historic reproduction carpeting was added soon after.

White Hall has received many accolades over the years. On March 11, 1971, the house was placed on the National Register of Historic Places.[378] Forty years later, on April 12, 2011, in recognition of Cassius M. Clay's newspaper the *True American*, the Society of Professional Journalists honored White Hall with a Historic Site in Journalism Award, making the mansion the ninety-ninth site in the United States with that distinction.[379]

The mansion is about ten thousand square feet. Guests at White Hall can be treated to a lengthy tour in which nearly every room and floor in the mansion are shown. It is a source of pride with the staff that the majority of the mansion is exhibited to guests. Only a few areas are inaccessible, due to the need for storage space. Unfortunately, because of the many floors and levels, the home is not handicap-accessible, as

there are 129 steps in and around the home that the guest would have to maneuver.

Since Cassius's time, the mansion has boasted about forty rooms. (Some say forty-two[380] and others say forty-four.) For those skeptical of the large number of rooms, one must consider that the large, expansive hallways are considered rooms, as are all of the closets (of which there are seventeen if you include the bathroom closets). In addition, the rooms located in the basement are also included in the number. For clarification purposes in the following list, when referring to the usage of the rooms, "Clermont" is in parenthesis after usage that would have taken place when the house was first completed in 1799 running up to the beginning of the new addition in the mid-1860s. "White Hall" is used to describe room usage from 1864 to 1903, and "modern" is used in reference to the usage and naming of the rooms after the home became a historic site. Although the names of the Clay children have been given to the rooms, it is not known who actually slept in the space.

- powder room (White Hall)
- first-floor hallway (White Hall)
- drawing room (White Hall)
- parlor (Clermont); dining room (White Hall)
- parlor (Clermont); library (White Hall)
- dining room (Clermont); pantry (White Hall)
- second-floor hallway (White Hall)
- bedroom (White Hall); Laura's room (modern)
- Laura's first closet (White Hall)
- Laura's second closet (White Hall)
- bedroom (White Hall); Sarah's room (modern)
- Sarah's first closet (White Hall)
- Sarah's second closet (White Hall)
- toilet closet (White Hall)
- wastewater disposal closet (White Hall)
- tub closet (White Hall)
- Green Clay's room and additional bedroom (Clermont); Cassius's room (White Hall)
- master bedroom (modern)
- master bedroom first closet (White Hall)
- master bedroom second closet (White Hall)
- master bedroom third closet (White Hall)
- additional room (White Hall); tower room (modern)

- bedroom (Clermont/White Hall); children's room (modern)
- bedroom (Clermont/White Hall); nursery (modern)
- attic space (Clermont); bedroom (White Hall); Anne's room (modern)
- attic space (Clermont); bedroom (White Hall); archives (modern)
- third-floor hallway (White Hall)
- bedroom (White Hall); Mary Barr's room (modern)
- Mary Barr's first closet (White Hall)
- Mary Barr's second closet (White Hall)
- bedroom (White Hall); Brutus's room (modern)
- Brutus's first closet (White Hall)
- Brutus's second closet (White Hall)
- bedroom (White Hall); history room (modern)
- history room first closet (White Hall)
- history room second closet (White Hall)
- basement hallway (White Hall)
- old warming kitchen (Clermont)
- old warming kitchen storage room (Clermont)
- jail (Clermont)
- first back fuel and heater storage room (White Hall)
- second back fuel and heater storage room (White Hall)
- possibly a wine cellar (White Hall); break room (modern)
- possibly a cook's residence office (Clermont/White Hall); business office (modern)
- new warming kitchen (Clermont); cooking kitchen (White Hall); event space (modern)

In addition, guests are also told that the mansion includes three main floors, and because of the differences in ceiling heights on the first floor, the house contains a total of nine levels, as follows:

- first floor
- second floor, new section
- second floor, old section
- tower room
- attic space/Anne's room/archives
- third floor
- basement
- new warming kitchen
- office

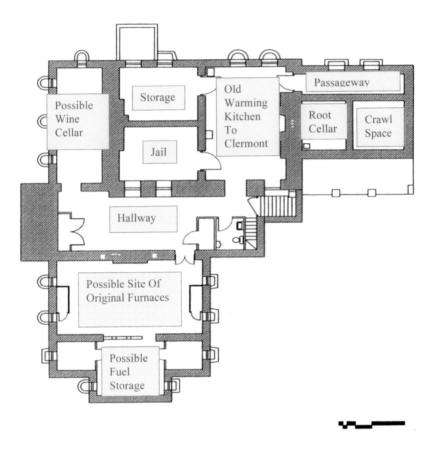

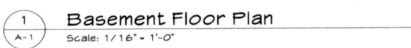

Basement Floor Plan

1 / A-1

Scale: 1/16" - 1'-0"

Floor plan of White Hall's basement. Text inserted by the authors. *Courtesy of Gregory Fitzsimons.*

While viewing the mansion, guests are treated to an exemplary tour. The staff continuously conducts research in order to remain up to date on the history of the site and the Clay family. In addition, the docents lead a tour that is more like a friend accompanying the guest through the home rather than a stiff and structured presentation. One former guide who trained new employees at White Hall relayed to the fresh docents, "First and foremost, this is your home. You're going to be here for eight hours a day, five days a week. This is your second home, so treat your guests like they're coming into

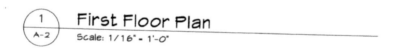

First Floor Plan
Scale: 1/16" = 1'-0"

1
A-2

Floor plan of White Hall's first floor. Text inserted by the authors. *Courtesy of Gregory Fitzsimons.*

your house and you're telling them about your family, because you are going to adopt the Clays and they are going to be your family."[381]

In addition to guided tours, the park and mansion have played host to many events throughout the years. In the first three decades of operation, historic reenactments were common on the grounds. The park has also welcomed car, antique and flower shows, as well as cultural events such as symphony orchestras and theatrical events. The mansion has been decked for the holidays off and on throughout the years and has been the setting

Second Floor Plan

Scale: 1/16" = 1'-0"

Floor plan of White Hall's second floor. Text inserted by the authors. *Courtesy of Gregory Fitzsimons.*

for ghostly appearances in the form of guided ghost tours and the annual *Ghost Walk*, an excellent theatrical production based on the Clay family's life. White Hall has also welcomed Green and Cassius's descendants and relatives back to their ancestral home by hosting a number of Clay family reunions. To successfully present these programs along with the normal guided tours takes a dedicated group of employees.

Staffing has changed drastically over the four decades the site has been open to the populace. Changes in tour operations, the addition and

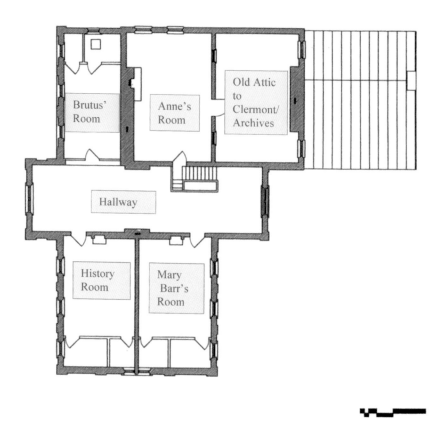

Third Floor Plan

1 / A-4

Scale: 1/16" = 1'-0"

Floor plan of White Hall's third floor. Text inserted by the authors. *Courtesy of Gregory Fitzsimons.*

subtraction of areas open to the public and the economy have all played important factors. Permanent full-time positions included a park manager who at the beginning was in charge of only White Hall up to a time when that post handled the operations of both White Hall and neighboring Fort Boonesborough Kentucky State Park in the mid-1970s, when the

fort opened. The manager position had then returned to just maintaining control over just White Hall by the late 1980s, lasting to early 1990s. A secretary, later referred to as a business office manager, was employed until the position was eliminated in 2004. Maintenance has fluctuated over the years—at one point having three positions to maintain the numerous acres and problem-prone house; in recent years there has only been one person to deal with the upkeep. From the beginning, a staff member has always been employed as a housekeeper of the massive home. In the mid-1990s, the position was transitioned to a curatorial type of role.

In terms of seasonal staff, upon opening in 1971, there were at least a dozen docents on staff, as well as a person employed in the gift shop.[382] This continued on into the 1980s. The large number enabled the interpreters to take a guest in to the mansion for a tour whenever they happened to arrive on the park.[383] By the mid-1990s, there was still one employee for the gift shop; however, the number of guides had been reduced to five. Set tour times were scheduled for guests, and so a smaller number of docents were needed. The stone kitchen and loom house had been restored and were opened to the public in 1995; therefore, a stone kitchen interpreter was also employed. This staffing model continued on until 2010 when, due to budgetary issues, the gift shop was closed down and the gift shop supervisor position eliminated. The stone kitchen and loom house, although still open for viewing by the public, was no longer staffed on a regular basis, and the tour guide staff was cut down to two interim positions. In spite of the increasingly reduced staff, guests can still expect to be greeted and given a stellar tour. The welcoming party is still there, just smaller.

As with any business, some staff members work at a site for a brief period, while others remain employed for years. Whether the time is short or long, many former employees reflect with fondness of their time at the "Big House," as White Hall is affectionately called. In 2011, to celebrate the fortieth anniversary of White Hall State Historic Site's opening to the public, a former employee reunion was organized. Employees from all four decades of operation attended and spent the evening reminiscing. When asked of their impressions of White Hall and the history, glowing accolades were numerous. One docent enthused, "White Hall is incomparable!"[384] Another stated, "It is such a special place; it stays with you forever."[385] Still another admitted, "It was more than a job; it was love."[386] One tour guide in particular, when asked to relate his best memory of White Hall, stated, "Too many. When I worked there it felt more like home than nearly anywhere I've ever been."[387] In contemplation of their legacy, don't you think the Clay family would be pleased?

A visitor to the home before restoration once commented, "There certainly is a great deal of heritage connected with this house. There are secrets hidden in all the dark corners of this brick mansion. No one will ever be able to reconstruct Cassius Clay's true story completely, but by just walking through his aged home, one comes to realize that many of his untold realities are dying as his house slowly crumbles away."[388]

Through the long progression of time, disinterest and neglect, a great deal of what is known about Cassius M. Clay, his family and his home has been lost. However, since the restoration and opening of White Hall, continued research and perseverance has allowed more of this remarkable story to be uncovered. Truly, not a week goes by that the authors do not discover some new facet about the Clays that adds another piece of the puzzle back to make the picture more complete. In years to come, more information will be discovered that will add new perspectives to what is already known about this great family and their fascinating home, and as a result it will make this work seem dated.

It had been a wish in one of Cassius M. Clay's wills that his home and land would be given to the government for "the finest natural park on earth."[389] It is the view of these authors that Clay would have approved of White Hall State Historic Site as it stands today. Guests are able to enjoy the beautiful mansion, outbuildings and grounds and imagine, for a time, what it might have been like to be a Clay.

Just as the potter is able to mold clay into numerous forms, so has White Hall State Historic Site gone through many transformations in its lifetime. The home originated with Green Clay as a single-family dwelling and became enlarged through Cassius Marcellus Clay and Mary Jane Warfield Clay as a political and personal showplace. The building went through what could be considered an "Odinsleep"[390] during the tenant farmer years and then experienced renewal through its restoration. It continues on today as a home with a rich and fascinating history of which Kentucky can be proud.

NOTES

PART I

1. Clay, *Clay Family*, 63–88; Clay Family Belcher Genealogy, "Clay Family." There are many sources published and unpublished, both online and in various books, that contain this information. These are just two of them.
2. Clay, *Clay Family*, 63–88; Clifton's Collectibles Genealogy, "Neale's Clays." There are many sources published and unpublished, both online and in various books, that contain this information. These are just two of them.
3. Clay, *Life of Cassius Marcellus Clay*, 17.
4. Ibid.
5. Collins, *Collins' Historical Sketches*, vol. 2, 143.
6. Clay, *Writings of Cassius Marcellus Clay*, xi.
7. Clay, *Life of Cassius Marcellus Clay*, 46.
8. Ibid., 39.
9. Payne, *Frontier Memories III*, 51.
10. Ibid.
11. This quote has often been credited to the showman P.T. Barnum. However, the banker David Hannum was more than likely the man who said the famous phrase in reference to the knock-off that Barnum created of the Cardiff Giant. Ironically, the Cardiff Giant also turned out to be bogus. It was created by George Hull (who claimed to have excavated the stone being) and purchased by Hannum and a group of investors.

12. Madison County Court Order Book B, 125. Green Clay initially studied under commissioned surveyor James Thompson; Collins, *Collins' Historical Sketches*, 142.

13. Madison County Court Order Book C, 15–16.

14. Clay, *Life of Cassius Marcellus Clay*, 45.

15. Cassius M. Clay to Sidney P. Clay, June 11, 1820, White Hall State Historic Site Archives.

16. Madison County Court Order Book B, 290–95.

17. *Lexington Reporter*, "Taverns to Rent." Green Clay had the advertisement: "Taverns to rent at Estill Court House and the Sweet Spring…The houses are large, new and well-furnished…the great resort of people to the Sweet Springs, which are within a half mile of the Court House, where all the leading roads to the upper country centre, make these places very valuable for public houses."

18. Madison County Court Order Book B, 125.

19. Madison County Court Order Book C, 484.

20. Madison County Court Order Books A and B.

21. Kentucky Court of Appeals Deed Books, January 1814, 325.

22. Old Kentucky Series Land Deeds, 1805–28, Kentucky Department for Library and Archives.

23. Ibid.

24. Madison County Court Order Book D, 310–12, 356, 374.

25. Commonwealth of Kentucky Circuit Court, "Bledsoe & Clay," private collection. Copy of reference in White Hall State Historic Site Archives.

26. French Tipton Papers, Special Collections and Archives, Eastern Kentucky University, vol. 1, 40, 53.

27. General Green Clay will, dated September 3, 1828, proved November 3, 1828, Madison County Court Order Book D, Richmond, Kentucky, 465. Copy in White Hall State Historic Site Archives.

28. Clay, *Life of Cassius Marcellus Clay*, 41.

29. Ibid., 41–42.

30. Green Clay will, Madison County Court Order Book D, 465.

31. Leslie R. Miller to Lashé D. Mullins, September 4, 2008, White Hall State Historic Site Archives.

32. Clay Family Belcher Genealogy, "Clay Family."

33. Clay, *Life of Cassius Marcellus Clay*, 22.

34. Ibid., 23.

35. Ibid., 41.

36. Ibid., 24.

37. Ibid.

38. Ibid., 21.

39. Ibid., 21–22.

40. Ibid., 21.

41. Ibid.

42. Harding, *George Rogers Clark and His Men*, 113.

43. Clay, *Life of Cassius Marcellus Clay*, 44.

44. Collins, *Collins' Historical Sketches*, 776.

45. Clay, *Life of Cassius Marcellus Clay*, 39.

46. Ibid., 46.

47. Ibid., 45.

48. Ibid., 38.

49. Green Clay to Sally Clay, January 8, 1820, Green Clay Collection, Filson Historical Society.

50. Clay, *Life of Cassius Marcellus Clay*, 40.

51. Collins, *Collins' Historical Sketches*, 521. Tanner's station is listed as being "80 yards nearly east of Gen. Cassius M. Clay's residence, six miles northwest of Richmond; settled by John Tanner in 1781, but Station not built until 1782."

52. Clay, "Whitehall," 3.

53. Clay, *Life of Cassius Marcellus Clay*, 20.

54. Ibid., 35.

55. Ibid., 40.

56. Green Clay to Helen, August 24, 1947, private collection. Copy in White Hall State Historic Site Archives.

57. Collins, *Collins' Historical Sketches*, 523.

58. Heflin, *Clay's of White Hall*, 3.

59. Green Clay will, Madison County Court Order Book D, 465.

60. Written on the inside cover of an original copy of Cassius M. Clay's *Life of Cassius Marcellus Clay*, vol. I: "Fort Gen. Green Clay—Now 'White Hall, Ky.' 10 25 1899," White Hall State Historic Site.

61. Mary Jane Warfield Clay, Cassius's first wife, makes reference to "the farm" in numerous letters from the 1840s.

62. Tate and Fitzsimons, "Initial Study."

63. Clay, *Life of Cassius Marcellus Clay*, 42.

64. Green Clay will, Madison County Court Order Book D, 465.

65. Cassius M. Clay to Sidney P. Clay, June 11, 1820, White Hall State Historic Site Archives.

66. Clay, *Life of Cassius Marcellus Clay*, 41.

67. Ibid., 45.

68. Clay, "Whitehall," 7.

69. Cassius M. Clay to Sidney P. Clay, June 11, 1820, White Hall State Historic Site Archives.

70. Wikipedia. "Clay County, Kentucky."

71. Clay, *Life of Cassius Marcellus Clay*, 38.

72. Green Clay will, Madison County Court Order Book D, 467.

73. Ibid., 465.

74. Madison County Courthouse, Richmond, Kentucky, restricted collection. Copy in White Hall State Historic Site Archives.

Part II

75. Many people today will ask if the famous boxer Muhammad Ali was named after Cassius M. Clay the emancipationist. Technically, Ali was named after his father, Cassius M. Clay Sr., as Muhammad Ali's birth name was Cassius M. Clay Jr. However, it is believed that both men acquired their name because of the original Cassius. A follow-up question is generally, "Was Ali and his family connected in any way with Cassius M. Clay the emancipationist?" Some would speculate that Muhammad Ali's ancestors were slaves of Cassius M. Clay. Others claim that they are direct descendants. In reality, solid supporting documentation has not been found at this point that directly relates the two houses. Having said that, research in African American roots in the United States is difficult at best. In reviewing Muhammad Ali's genealogy, there simply is no concrete evidence that Ali is a blood relation of Cassius or a descendant of slaves once owned by him. The name coincidence may have simply been in honor of the original Cassius M. Clay and nothing more.

76. Clay, *Writings of Cassius Marcellus Clay*, xii.

77. Clay, *Life of Cassius Marcellus Clay*, 22, 34.

78. Ibid., 47.

79. *The Transylvanian*, "Burning of the Main Building," 452–54.

80. Clay, *Life of Cassius Marcellus Clay*, 164.

81. Ibid., 55.

82. Ibid., 23.

83. Ibid., 25.

84. Ibid., 25–26.

85. *Commonwealth v. Mary a Slave*, May 18, 1820–October 10, 1821, Kentucky Department for Library and Archives, Frankfort, Kentucky.

86. Clay, *Life of Cassius Marcellus Clay*, 27.

87. Commonwealth Warrant of Reprieve, November 16, 1821, Kentucky Department for Library and Archives, Frankfort, Kentucky.

88. Madison County Court Order Book D, 464.

89. Clay, *Life of Cassius Marcellus Clay*, 25.

90. Ibid., 45.

91. Ibid., 27.

92. Ibid., 25.

93. Smiley, *Lion of White Hall*, especially 48 and 57, discusses this topic well.

94. Clay, *Life of Cassius Marcellus Clay*, 25.

95. Clay, *Writings of Cassius Marcellus Clay*, 292

96. Madison County Court Order Book D, 462.

97. Cassius M. Clay to John G. Fee, 1855, Kentucky Department for Library and Archives, Frankfort, Kentucky.

98. Clay, *Life of Cassius Marcellus Clay*, 559.

99. Ibid., 560.

100. There are several letters in which Cassius discusses the issue of slavery to his brother Brutus, and almost in the same breath, Cassius would ask his brother if he could use his slaves. Perhaps these were trust slaves, and Cassius felt somehow entitled.

101. *Commonwealth v. Emily*, April 15, 1845, Kentucky Department for Library and Archives, Frankfort, Kentucky. Emily was acquitted of this crime, but she was still sold south by Cassius. Clay discussed Emily and his reasons for selling her in his *Memoirs*, 559–65.

102. *New York Times*, "Cassius M. Clay's Ready Pistol"; *Courier-Journal*, "Verdict of the Coroner's Jury." Cassius discussed Perry White in his *Memoirs*, 560–69.

103. Clay, *Life of Cassius Marcellus Clay*, 106.

104. Ibid., 58.

105. The most famous racehorse that Elisha Warfield would breed was Lexington. Although a great racehorse that won six out of his seven starts, Lexington's real claim to fame was that he was the leading sire in the latter part of the nineteenth century in North America sixteen times. Lexington's bones belong to the Smithsonian. For further reading, try Clark, "Dr. Warfield's Colt Lexington," *The Kentucky*, 266–81.

106. Clay, *Life of Cassius Marcellus Clay*, 66.

107. Ibid., 47.

108. Clay, "Dora, My Child Wife." In this article, Cassius wrote, "I am six feet high in socks and slippers without heels." In the summer of 2012, an analysis was done on Cassius's height. Dimensions were taken from a photograph of Cassius M. Clay standing in military dress, with a presentation sword at his side. The sword, which White Hall owns, was measured and then the size converted into the photograph. Based on the size of the sword in comparison to the size of Clay in the picture, it was determined that Cassius was about five foot eight. It's possible that Clay could have been exaggerating; however, his father, Green, was also rather tall, according to *Collins' Historical Sketches*.

109. Ibid. Clay stated, "I have weighed, throughout the prime of life, 183 pounds."

110. Clay, *Life of Cassius Marcellus Clay*, 162.

111. Ibid., 35.

112. Ibid., 67–68.

113. Ibid.

114. Marriage Book Number 1, Fayette County Courthouse, Lexington, Kentucky, 115. Cassius and Mary Jane were married on February 26, 1833.

115. Clay, *Life of Cassius Marcellus Clay*, 71–73.

116. Ibid., 74.

117. Lancaster, *Antebellum Architecture of Kentucky*, 145.

118. Clay, *Life of Cassius Marcellus Clay*, 73.

119. *Louisville Courier-Journal*, "Peaceful End."

120. Even while he was alive, there were legends floating around about Clay's fighting nature. Clay debunked one of these myths in his *Memoirs*, 75. "The legend goes, and was so illustrated by an engraving, that I placed a pistol on the book-board, and a Bible by its side saying: 'For those who obey the rules of right, and the sacred truths of the Christian religion, I appeal to this Book; and to those who only recognize the law of force, here is my defense,' laying my hand upon my pistol. Thus related, it would seem that I had made a prepared and threatened exhibition of my courage and prowess, when, in fact, I was exerting all my powers of appeal and argument to avoid a conflict; for such avoidance was victory. Had I laid my pistol on the book-board, some enemy was most likely to seize it. I had by carpet-bag with my arms and notes, as usual, at my feet, unseen; and the Bible on the board was always left there in the country meeting-houses."

121. Ibid.

122. Sally Lewis Clay Dudley to Cassius M. Clay, August 2, 1840, J.T. Dorris Collection.
123. For the full description in Cassius's words regarding the Robert Wickliffe duel, see Clay's *Memoirs*, 80–82.
124. Dudley to Clay, August 2, 1840.
125. Clay, *Life of Cassius Marcellus Clay*, 82.
126. For Cassius's view on the Samuel Brown fight, see Clay's *Memoirs*, 82–85.
127. Clay, *Life of Cassius Marcellus Clay*, 84.
128. *Clay v. Commonwealth*, September 19, 1843, Kentucky Department for Library and Archives.
129. Clay, *Life of Cassius Marcellus Clay*, 86–90.
130. This had been done in the past to other antislavery publications. Clay was well aware of the risk, as he mentions on page 106 of his *Memoirs*.
131. Clay, *Life of Cassius Marcellus Clay*, 107.
132. Ibid., 109
133. Ibid., 175.
134. Ibid., 108.
135. *Observer & Reporter*, "Gen. C.M. Clay's Arrival." In this article, there is a description of the welcome Cassius received when he returned home from the Mexican-American War.
136. Clay, *Life of Cassius Marcellus Clay*, 167.
137. Ibid.
138. For Cassius's words on the Cyrus Turner fight, check out his *Memoirs*, 184–86.
139. In numerous letters to Mary Jane, Cassius never failed to mention at the end of his letters to "Kiss Annie" for him, as well as remembering him to the other children.
140. *Filson Club History Quarterly*, "Biography of Cassius M. Clay," 254–55.
141. Clay, *Life of Cassius Marcellus Clay*, 570–71.
142. Ibid., 212.
143. Cassius may have given Fee all of the credit in his 1886 *Memoirs*, but a decade later, he would have a battle of words with Fee in the newspapers over who deserved accolades concerning Berea College. In an August 22, 1896 article, "Grows Warm," from an unknown paper, Fee claimed that "for the last forty years he has been the leading spirit of that famous institution." This is in retaliation for Clay's statement made in an earlier publication that Clay was the "undisputed founder, donor and defender" of the college.

144. Clay, *Life of Cassius Marcellus Clay*, 232.

145. Ibid., 233.

146. Ibid.

147. Ibid., 324.

148. Ibid., 249–57.

149. Mary Jane Warfield Clay to Katy, March 12, 1861, Special Collections and Archives, University of Kentucky.

150. Clay, *Life of Cassius Marcellus Clay*, 269–72.

151. Ibid., 299.

152. Simon Cameron wanted to pass a policy that allowed fugitive slaves into armed military service, a view too radical at the time for Lincoln.

153. Clay, *Life of Cassius Marcellus Clay*, 310.

154. Ibid., 310–12.

155. Ibid., 312.

156. Ibid., 236–37.

157. Ibid., 238.

158. Clay, *Oration of Cassius Marcellus Clay*, 3.

159. Cassius M. Clay's tombstone reads that he was born on October 10, 1810, and died on July 23, 1903. In reality, Clay was born on October 19, 1810, and died on July 22, 1903.

160. Mary Jane Warfield Clay to Laura Clay, March 25, 1863, Special Collections and Archives, University of Kentucky.

161. Clay, *Life of Cassius Marcellus Clay*, 107.

162. Lancaster, "Major Thomas Lewinski," 19.

163. Coleman, *Sketches of Kentucky's Past*, 71.

164. Lancaster, "Major Thomas Lewinski," 13. McMurtry apprenticed for a short time with architect Gideon Shryock.

165. Fountain City Tennessee History, "Fountain City Places that Made a Difference—Botherum." Although this website mainly deals with certain buildings of architectural interest in Lexington, Kentucky, there is also some information regarding builders of the time.

166. Lancaster, *Back Streets*, 79–80. Lancaster relates that McMurtry makes this claim in "Observations on Architecture," published in the *Lexington Daily Press* on June 2, 1887.

167. Lancaster, "Metamorphosis of Clermont," 10.

168. Mary Jane Warfield Clay to Laura Clay, May 23, 1864, Esther Bennett Collection.

169. Mary Jane Warfield Clay to Laura Clay, November 27, 1863, and Brutus Clay to Laura Clay, February 4, 1866, Esther Bennett Collection.

The 1863 letter has Mary Jane stating, "There were <u>secrets</u> in my letters which was the reason I wanted any letters burned. You are fond of secrets & therefore I wrote to you." In the 1866 letter, Brutus mentioned to Laura that Mary Jane (again) wants Laura to burn all of her letters.

170. Mary Jane Warfield Clay to Laura Clay, April 18, 1863, Esther Bennett Collection.

171. Mary Jane Warfield Clay to Laura Clay, January 25, 1864, Esther Bennett Collection.

172. Mary Jane Warfield Clay to Laura Clay, March 13, 1864, Esther Bennett Collection.

173. Mary Jane Warfield Clay to Laura Clay, April 27, 1864, Esther Bennett Collection.

174. Sallie Lewis Clay to Laura Clay, April 29, 1864, Esther Bennett Collection.

175. Mary Jane Warfield Clay to Laura Clay, May 23, 1864, Esther Bennett Collection.

176. Mary Jane Warfield Clay to Laura Clay, June 3, 1864, Esther Bennett Collection.

177. Brutus Junius Clay to Laura Clay, November 19, 1864, Esther Bennett Collection.

178. Clay, "Whitehall," 5.

179. Sarah Lewis Clay to Laura Clay, December 5, 1864. Letter on loan from Bennett family, White Hall State Historic Site Archives.

180. Mary Barr Clay to Mary Jane Warfield Clay, January 12, 1865, Esther Bennett Collection.

181. Sarah Lewis Clay to Laura Clay, October 18, 1865, Esther Bennett Collection.

182. Cornelia Walker Clay to Laura Clay, December 3, 1865, Esther Bennett Collection.

183. Sarah Lewis Clay to Laura Clay, January 14, 1866, Esther Bennett Collection.

184. Mary Jane Warfield Clay to Laura Clay, January 20, 1866, Esther Bennett Collection.

185. Mary Barr Clay Herrick to Mary Jane Warfield Clay, January 18, 1866, Esther Bennett Collection.

186. Laura Clay to Mary, June 19 and 20, 1861. Original location unknown, copy in White Hall State Historic Site Archives.

187. Mary Jane Warfield Clay to Jule, October 28, 1861, Bill Scott Collection.

188. Ibid.

189. Ibid.

190. This room is set up in the museum today as having a sink in it. A recently discovered photograph shows the original wooden structure to have been too low to serve as a sink. Because of the height placement, some believe that the room actually had a toilet or urinal in this room. However, because the door will not shut and give the person privacy, the most reasonable explanation for this room's usage is that of a wastewater disposal area.

191. Mary Jane Warfield Clay to Laura Clay, April 27, 1866, Esther Bennett Collection.

192. Mary Barr Clay to Laura Clay, November 12, 1863, Esther Bennett Collection.

193. Mary Jane Warfield Clay to Laura Clay, April 27, 1864, Esther Bennett Collection.

194. Mary Jane Warfield Clay to Laura Clay, October 18, 1864, Esther Bennett Collection.

195. Mary Jane Warfield Clay to Laura Clay, April 27, 1866, Esther Bennett Collection.

196. Mary Jane Warfield Clay to Laura Clay, May 11, 1864, Esther Bennett Collection.

197. Mary Jane Warfield Clay to Laura Clay, March 24, 1864, Esther Bennett Collection.

198. Mary Jane Warfield Clay to Laura Clay, April 27, 1866, Esther Bennett Collection.

199. Mary Jane Warfield Clay to Laura Clay, January 14, 1866, Esther Bennett Collection.

200. Mary Jane Warfield Clay to Laura Clay, April 13, 1866, Esther Bennett Collection.

201. Mary Jane Warfield Clay to Laura Clay, May 27, 1866, Esther Bennett Collection.

202. Mary Jane Warfield Clay to Laura Clay, March 1866, Esther Bennett Collection.

203. Mary Jane Warfield Clay to Laura Clay, April 13, 1866, Esther Bennett Collection.

204. Mary Jane Warfield Clay to Laura Clay, April 27, 1866, Esther Bennett Collection.

205. Cassius M. Clay to Mary Jane Warfield Clay, December 15, 1864, original location unknown.

206. Ibid.

207. Mary Jane Warfield Clay to Laura Clay, May 27, 1866, Esther Bennett Collection.

208. Mary Jane Warfield Clay to Laura Clay, undated, Esther Bennett Collection.

209. Ibid.

210. *The Beverly Hillbillies* comedy show ran on CBS from 1962 to 1971.

211. Historic American Buildings Survey, "White Hall."

212. See Sally Clay's October 18, 1865 letter to Laura Clay and Cornelia Walker Clay's December 3, 1865 letter to Laura Clay.

213. This is evidence by 1960s pre-restoration photographs taken of the basement by Mr. James Cox of Madison County.

214. Clay, "Whitehall," 4.

215. Ibid., 8. All of the recollections of the flora and fauna in this paragraph have come from this writing.

216. Ibid., 7–8.

217. These buildings still exist today and are part of the park.

218. Clay, "Whitehall," 8.

219. Cassius M. Clay to "Doctor," circa 1876, Thomas D. Clark Collection, Kentucky Historical Society. Copy in White Hall State Historic Site Archives.

220. Clay, *Life of Cassius Marcellus Clay*, iv.

221. Mary Jane Warfield Clay to Laura Clay, December 29, 1879, Esther Bennett Collection.

222. Census records for 1870 show Cassius M. Clay, age sixty, residing in Yonkers, New York. Interestingly, Clay's occupation listed at the time was oil merchant. Also around this time, Clay could add inventor to his professional list, as he had patented a gasoline lamp. Patent 80137, July 21, 1868, manufactured at C.M. Clay & Company, 45 Liberty Street, New York, www.//lampguild.org/QandApage/archivesQ0003513.htm.

223. Clay, *Life of Cassius Marcellus Clay*, 547.

224. Ibid.

225. Cassius M. Clay to Mary Jane Warfield Clay, December 29, 1850, White Hall State Historic Site Archives.

226. Clay, *Life of Cassius Marcellus Clay*, 548.

227. Julian Hawthorne, a reviewer in the *New York World*, made this assumption, prompting Cassius to state, "I have no enmity towards Mrs. C., and should feel bound to defend her against such attacks as Hawthorne's for her children's sake if justice to her did not demand it." For this, Hawthorne apologized to Clay, and the two did not duel. Interestingly, this defense of

Mary Jane took place many years after their divorce, when Cassius was seventy-six years old.

228. McQueen, *Freedom's Champion*, 41. McQueen quoted a section of this letter but did not give a citation for it.

229. Clay, *Life of Cassius Marcellus Clay*, 540.

230. Ibid., 160–61

231. Clay, "Dora, My Child Wife."

232. Cassius M. Clay to Mary Jane Warfield Clay, October 21, 1865, White Hall State Historic Site Archives.

233. "Public Sale," unknown newspaper, April 15, 1856. Clay's house, possessions, livestock and slaves would go up for auction as a result of the bankruptcy.

234. To put this amount into perspective, in today's money the final cost of the building—if the bill was paid in 1867, when the mansion was more than likely completed—would have been around $57,900,000. www.measuringworth.com.

235. Clay, *Life of Cassius Marcellus Clay*, 541.

236. Cassius M. Clay to Mary Jane Warfield Clay, October 21, 1865, White Hall State Historic Site Archives.

237. Clay, *Life of Cassius Marcellus Clay*, 547–48.

238. Ibid., 436–37.

239. Ibid., 467.

240. Ibid., 463–64.

241. Ibid., 468.

242. The Chautum story ran in the *Cincinnati Commercial*, and Clay's retort was placed in the *Register*.

243. According to Cassius, Mary Jane's accusations took place in 1866, and he was so disgusted and hurt by her disbelief in him that he stopped writing her.

244. Clay, *Life of Cassius Marcellus Clay*, 540.

245. Ibid., 549.

246. *Cassius M. Clay v. Mary Jane Clay*, December 28, 1877–February 7, 1878, Kentucky Department for Library and Archives.

247. It was a stipulation in the divorce that Mary Jane could not remarry while Cassius was still alive.

248. Although the womenfolk in his family were women's suffrage advocates, Cassius M. Clay took a decidedly chauvinistic opinion. When asked his view on the subject once, he replied in an October 15, 1884 *Courier-Journal* interview, "I have no objections to it, but I think women make better bed-

fellows than voters. Notice the whole animal kingdom, and you will see the males rule."

249. Sarah Lewis Clay to Laura Clay, December 5, 1864, White Hall State Historic Site Archives, reference to fear of house burning. Mary Jane Warfield Clay to Laura Clay, March 8, 1863, Esther Bennett Collection, reference to horse thieves.

250. Mary Jane Warfield Clay to Laura Clay, May 23, 1864, Esther Bennett Collection.

251. *Louisville Courier-Journal*, "Lonnie Clay's Arrival at Richmond."

252. Madison County Courthouse, August 11, 1873. This particular record stating that Cassius M. Clay adopted Leonide Petroff and changed his name to Launey Clay is not in the public records. Permission was granted to the curator to view the document by the Madison County clerk in 2012.

253. Clay, *Life of Cassius Marcellus Clay*, 555.

254. Clay, "Dora, My Child Wife."

255. *Louisville Courier-Journal*, "Happy With His Bride."

256. Clay, *Life of Cassius Marcellus Clay*, 550.

257. Ibid., 554.

258. Clay, "Dora, My Child Wife."

259. Ibid.

260. Ibid. Clay compared Dora to Tiziano Vecellio's (known in English as Titian) painting *Young Woman at her Toilette* (1515), where a girl of radiant complexion holds a portion of her long red hair while gazing into a mirror.

261. *New York Times*, "Gen. Clay Weds Pretty Dora." According to this short article, the marriage took place at ten o'clock in the morning, with Squire B. Douglass as the officiant.

262. Ibid. As the reader can see from the newspaper, even those in New York could read about the marriage.

263. Although countless newspapers of the time reported that Dora Richardson was fifteen years old when she married Cassius, some (including her descendants, who stated she was thirteen) claimed that Dora was younger. Clay himself stated in the newspaper article "Dora, My Child Wife," "[S]he was really not fourteen." Although an actual birthdate has not been found at this point for Dora, numerous sources stated that she was born in 1880. By this rationale, Dora could actually have been fourteen at the time of her marriage. When Dora passed away in 1814, several papers reported her age as thirty-five, so Dora could have been born as early as 1879, making her descendants right in their claims that she was indeed thirteen years old.

264. Odem, *Delinquent Daughters*, 14. This age is listed for Kentucky for the year 1885, so it is assumed that the year before would had the same age qualifications. Surprisingly, twelve was not the youngest age that a girl could marry at the time. Delaware's legal age of consent was seven years old!

265. *Courier-Journal*, "The Sage of White Hall."

266. Ibid.

267. *Lexington Herald-Leader*, "Bodyguard's Notes Concerning Cassius Clay I Are Revealing." At the time of his second marriage, Cassius had a bodyguard working for him who years later recorded his recollections of his time in employment to Clay. John J. James's reminiscences give insight on what it was like to live around White Hall and also show a little of how Cassius's mind was working at the time. Although the memoir was written thirty-seven years after James ended his employment with Clay, it is the belief of the authors that there is still great merit in what he recorded.

268. One of the most treasured stories regarding Cassius and the posse that came to rescue Dora involves what is referred to as the "Dear Judge" letter. In this correspondence, supposedly the leader of the posse, Sherriff Josiah P. Simmons, made a report back to the county judge, John C. Chenault, about the fight that occurred in the group's attempt to "rescue" Dora. It is a funny epistle, and its only known source is William H. Townsend. He used the letter in his "Lion of White Hall" speech. The original letter has never resurfaced, and it was discovered in 2011 that Josiah Phelps Simmons, who supposedly wrote the letter, actually died in 1885, a full nine years before the letter was even written.

269. Clay, "Dora, My Child Wife." Clay included multiple letters in this article that were written by him to Dora and vice versa.

270. *New York Times*, "Gen. Clay Divorced." The divorce restored Dora back to her maiden name.

271. *New York Times*, "Wants Child Wife Back."

272. Dora's son was named Cassius Marcellus Clay Brock.

273. *San Francisco Call*, "Aged General Clay Besieged by Women." The ages of the women who proposed to Clay ran the gamut from middle-aged women to girls.

274. The "Lion of White Hall" was a moniker given to Cassius because of his fiery nature and long flowing mane-like hair.

275. The children actually paid Cassius rent for their family farms. Once Clay passed away, they received the land as their own.

276. Clay, *Life of Cassius Marcellus Clay*, 550.

277. *Courier-Journal*, "Cassius M. Clay."

278. General Green Clay will, dated September 3, 1828.

279. *Courier-Journal*, "Cassius M. Clay."

280. *Mount Sterling Advocate*, "The Famous Herd."

281. *Courier-Journal*, "Cassius M. Clay."

282. *The Culture of Watermelons* is framed and hangs on display in the History Room of White Hall State Historic Site.

283. On one tour in the 1990s, a visitor mentioned to the curator that one of his ancestors relayed the story of a visit to Cassius. This gentleman was offered watermelon by Clay, which he politely declined. A few minutes later, Cassius once again offered some watermelon, which was again refused by the guest. The third time, Clay made an offer by stating, "I *said* do you want some watermelon!" To this, the guest then nervously accepted a slice.

284. *Courier-Journal*, "Clay."

285. Ibid. Clay would also discuss how the seeds in his watermelon were "as white as snow." Evidently, Cassius had perfected the art of "seedless" watermelons way before they became popular.

286. *Courier-Journal*, "Clay."

287. Ibid.

288. Ibid. Interestingly, the front hall is decorated much this same way today, with even the czar in the sleigh being hung on the right wall, and this article was found years after the decorating took place.

289. *Courier-Journal*, "Historic Homes of Kentucky." Cassius went on to state that he didn't think a landscape would be complete without sheep and that in England and in the eastern part of the United States, sheep were "placed in the public park as ornaments."

290. *Louisville Courier-Journal*, "Sage of Whitehall."

291. Some venture that the third intruder was actually Riley Brock, Dora Richardson Clay Brock's second husband. Perhaps Riley had seen what the old man had while he was working at the estate and thought that he would be easy to rob. This is, however, simply speculation, as the third man was never positively identified.

292. This is a much-loved and long-cherished narrative about Cassius. Up until this juncture, there has not been any primary source proof that the account ever took place. This story is included because it is a wonderful tale and, at this point, cannot be disproved.

293. *Atlanta Constitution*, "Vendetta." According to this account, Clay wanted to give Dora an interest in his estate. He had sent Mary Barr out to talk to her siblings about his request, and when she returned, he did not believe

her answers to him. Cassius reportedly put a gun to Mary Barr's head and told her, "[L]eave my house and never come here again."

294. *Daily Leader*, "Cassius Clay: Opens Fire"; *Daily Leader*, "Is Gen. Clay Wounded?"; *Sunday Leader*, "Dead Line."

295. *Lexington Leader*, "Siege of White Hall."

296. *Daily Leader*, "Holds the Fort Alone."

297. *Bourbon News*, "A Constable."

298. *Mount Sterling Advocate*, "To Take Charge."

299. *San Francisco Call*, "General Cassius M. Clay Is Deprived of Weapons."

300. Pope Leo XIII passed away on July 20, 1903, two days before Cassius M. Clay.

301. Reportedly, when told of the pope's demise, Clay quipped with, "Well, I won, and I'm not even infallible."

302. *Louisville Courier-Journal*, "Peaceful End."

303. *Morning Herald*, "Will." Interestingly enough, Cassius's father, Green Clay, had assisted in the establishment of this particular church.

304. *Lexington Leader*, "Death Mask." This is stated in Clay's June 21, 1900 will but also in this particular article, which also reported that African American sculptor Isaac Scott Hathaway made a death mask of Cassius.

305. *Cincinnati Enquirer*, "Tribute."

306. *Richmond Climax*, "One of His Wills."

PART III

307. See one of Cassius Clay's many wills.

308. *Lexington Leader*, "Gen. Clays Treasures."

309. Report of Sale list copy in White Hall archives.

310. The *Central Record* had fun with this turn of events in an August 14, 1903 edition. The paper reported, "Gen. Cassius M. Clay, 'the Old Lion,' who was known in life as a fighter, in every sense of the word, seems to have determined to keep the ball rolling after death, as he left six wills for the courts to grind on."

311. *Morning Herald*, "Will." White Hall also has several original copies of Cassius M. Clay's will.

312. *Lexington Leader*, "All Wills Void."

313. Numerous contemporary papers reported that Dora declared she would contest the court ruling, but no evidence has been found up until this point that proves she actually did. Many people will ask what ever

became of Dora. After marrying five times, she died at the age of thirty-five (or possibly thirty-four) of tuberculosis on February 11, 1914. *Lexington Herald*, "Former Wife of General Cassius M. Clay." Dora was not even to have a legitimate marker. Years later, the Kentucky Historical Society would put up a small metal plaque in Midway Cemetery to memorialize the final resting spot of a girl who once caused national headlines for her matrimony to a man almost six times her age.

314. *Lexington Leader*, "White Hall."

315. Ann Bennett, in an e-mail recollection to Lashé Mullins, June 27, 2012.

316. Ibid.

317. This information was derived from interviews with people familiar with the estate, as well as from studying the agricultural census records from the time.

318. A guest at White Hall in the summer of 2012 once worked on the estate in Warfield Bennett's time and recalled hauling hay bales up to the second story for storage.

319. Johnny Cox, the current farm manager for Bennett farm, has worked on the farm since he was a young man, and he recalled a tractor parked in the front hallway in the years before restoration.

320. Schweder, "Whitehall."

321. Ann Bennett to Lashé Mullins, e-mail.

322. Betty Alexander, in phone interview with Lashé Mullins, April 2012.

323. Schureman, "Cassius Clay's Decaying Mansion," 7.

324. Judy Ballinger King, in an interview with Lashé Mullins, September 7, 2012.

325. Ibid.

326. *Courier-Journal & Times*, "Kentucky to Exorcise Ghosts." The first trespassers to leave their names and dates on the walls visited not even a year after Clay's death, for the date of 1904 was written beside the signatures.

327. Balke, "Whitehall's Furnishings Coming Home."

328. The last tenants to live in the mansion were the McKinney family. A daughter of the family visited in the summer of 2009 and relayed this story to the park manager and curator.

329. White Hall Guest conversation with Lashé Mullins in 2009.

330. Nina Berlin in a discussion with Lashé Mullins, July 26, 2012

331. James Cox, in an interview with Lashé Mullins, July 26, 2012.

332. Ibid.

PART IV

333. *Louisville Courier-Journal & Times*, "White Hall's Lion."

334. Helen Chenault, in an interview with Lashé Mullins, August 14, 2012.

335. Ibid.

336. Ibid.

337. *Madison County Newsweek*, "White Hall Restored."

338. Ibid.

339. James Cox interview.

340. Ellison, *Man Seen But Once*, 188.

341. Martinson, *Historic American Buildings Survey*.

342. Historic American Buildings Survey, "White Hall." Copies of the initial report are housed in White Hall Archives; however, elevation drawings can be viewed online.

343. In a July 11, 1967 letter from the Assistant Commissioner of Kentucky Department of Parks Albert Harbenson to Thruston Moore of Heather Enterprises, Harbenson discussed the steps that had already taken place in preparation for White Hall to be purchased by the State of Kentucky.

344. Madison County Court Order Book 236, 290–96.

345. Lancaster, "Metamorphosis of Clermont," 6.

346. Ellison, *Man Seen But Once*, 189.

347. Ibid.

348. Even today, the copper lining is the bane of the curator's existence, as it is very hard to polish; on the flip side, though, it is very striking once cleaned.

349. When viewing the cistern from a crawl space below located in the bathtub closet, one can see the original locations of these drains. The drains seen from the third floor are not in the initial locales.

350. Ellison, *Man Seen But Once*, 189.

351. Ibid., 190.

352. This information is based on numerous Kentucky state letters and memos that were perused by the curator.

353. Nolan, "White Hall."

354. Coleman, *Joel T. Hart*. Hart took the bust he made of Clay overseas to drum up business. In 1838, Hart made a bust of Andrew Jackson, who stated that Hart "may be ranked with the best artists of the age."

355. *Richmond Register*, "Cassius M. Clay's Cannon."

356. Nancy Turner, Former Employee Questionnaire, September 2011, White Hall State Historic Site Archives.

357. For more information on this affliction, see Porter and Rousseau, *Gout*.

358. An advertisement for Clay's *Memoirs* was found discussing the works' subject matter, the four grades the book was available in for purchase (along with the cost associated with each grade) and a timeline for which volumes 1 and 2 were to be delivered to the purchaser. A copy of this advertisement is located in White Hall Archives.

359. Clay, *Life of Cassius Marcellus Clay*, 301.

360. Mary Jane Warfield Clay to Julia, October 28, 1862, Bill Scott Collection.

361. Mary Barr Clay to Mary Jane Warfield Clay, February 1864, Esther Bennett Collection.

362. A picture of Bullock with a short description was found in the scrapbook of Green Clay (Mary Barr Clay's son).

363. Fortune, "Past Comes Home."

364. *Courier Journal & Times*, "Whitehall's Restoration Is Viewed."

365. Memorandum from Commissioner S.W. Palmer-Ball to Commissioner Albert Chisten, July 6, 1971. The drive originally was meant to be cobblestoned with bricks.

366. Sutton, "Beula Nunn Winds Up Her 'Job.'"

367. Ellison, *Man Seen But Once*, 189.

368. Sutton, "Beula Nunn Winds Up Her 'Job.'"

369. *Richmond Daily Register*, "Cassius Clay's Freedom Goal."

370. *Courier Journal*, "Clay Mansion Bought by State."

371. Fortune, "Past Comes Home."

372. *Courier-Journal & Times*, "White Hall." There is some debate on the actual final price tag for the restoration; some state that the work cost upward of $1 million or more. The amount given in this book is the official sum given by the Kentucky Department of Parks in 1971.

PART V

373. Unknown newspaper, "Madison Countians' Day."

374. *Richmond Daily Register*, "Cassius Clay's Freedom."

375. Ibid.

376. Bean, "White Hall Dedicated."

377. According to Kentucky State Park letters and memos viewed by the authors, the name change would have taken place in 1986.

378. National Register of Historic Places, "Kentucky—Madison County." Although basic information can be accessed online, a copy of the nomination form is located in the White Hall Archives.

379. Interestingly, the call letting the curator know that White Hall was to be honored with this award came on October 19, 2010, the 200th anniversary of Cassius M. Clay's birth. What a birthday present!

380. *Courier-Journal & Times*, "Historic Homes of Kentucky."

381. Paula White, interview with authors, May 12, 2012.

382. Ibid.

383. Ibid.

384. Barbara McMahan, Former Employee Questionnaire, September 2011, White Hall State Historic Site Archives.

385. Turner questionnaire.

386. Paula White interview.

387. Ben Fryer, Former Employee Questionnaire, September 2011, White Hall State Historic Site Archives.

388. Schureman, "Cassius Clay's Decaying Mansion," 13.

389. See Cassius M. Clay's March 1901 will.

390. In Norse mythology, Odin was a god who once a year would undergo a deep, twenty-four-hour deathlike sleep, after which he would revive rejuvenated and stronger.

Bibliography

Atlanta Constitution. "'Vendetta' Gen. Clay Shouted, and Then Fierce Battle Began." April 6, 1901.

Balke, Betty Tevis. "Whitehall's Furnishings Coming Come." *Courier-Journal & Times*, October 20, 1968.

Bean, Dottie. "White Hall Dedicated: Home of Abolitionist Cassius Clay in Madison County Formally Becomes Shrine." *Lexington Herald*, September 17, 1971.

Bly, Sally. "Kentucky to Exorcise Ghosts of Whitehall's Unhappy Past." *Courier-Journal & Times*, April 9, 1967.

Bourbon News. "A Constable Succeeded in Serving on Cassius M. Clay." April 30, 1901.

Cincinnati Enquirer. "Tribute: Paid to His Memory." July 26, 1903.

Clark, Thomas D. "Dr. Warfield's Colt Lexington." In *The Kentucky.* Lexington, KY: Henry Clay Press, 1969.

Clay, Cassius M. "Dora, My Child Wife." *New York Journal,* January 16, 1898.

———. *The Life of Cassius Marcellus Clay: Memoirs Writing and Speeches.* Vol. 1. Cincinnati, OH: J. Fletcher Brennan & Company, 1886.

———. *Oration of Cassius Marcellus Clay Before Students and Historical Class of Berea College, Berea, Ky. October 16, 1895.* Berea, KY: Pantagraph Job Works, 1896.

———. *The Writings of Cassius Marcellus Clay Including Speeches and Addresses.* Ed. Horace Greeley. New York: Harper and Brothers, 1848.

Clay Family Belcher Genealogy in America. "Clay Family." http://freepages. genealogy.rootsweb.ancestory.com/~genbel/main/clayfamily.html.

Clay, Green. "Whitehall: The Birthplace and Home of General Cassius M. Clay." Unpublished, n.d. White Hall Archives.

Clay, Mary Rogers. *The Clay Family*. Louisville, KY: John P. Morgan and Company, 1899.

Clifton's Collectibles Genealogy. "Neale's Clays." http://www.nkclifton.com/clay/clay.html.

Coleman, J. Winston, Jr. *Joel T. Hart: Kentucky Sculptor*. Lexington, KY: Winburn Press, 1962.

——. *Sketches of Kentucky's Past: A Series of Essays Concerning the State's History*. Lexington, KY: Winburn Press, 1979.

Collins, Lewis, and Richard H. Collins. *Collins' Historical Sketches of Kentucky*. Vol. 2. Covington, KY: Collins & Company, 1874.

Courier-Journal. "Cassius M. Clay: A Talk with the Distinguished Retired Kentucky Politician." May 18, 1884.

——. "Cassius M. Clay: Visit to the Home of the Noted Southern Abolitionist." October 4, 1892.

——. "Clay Mansion Bought by State." July 30, 1968.

——. "Gen. Cassius M. Clay's Vulgarity About Female Suffrage—Indignation at the Arrest of Citizens." October 15, 1884.

——. "The Sage of White Hall." November 18, 1894.

——. "Verdict of the Coroner's Jury that Gen. C.M. Clay Killed Perry White in Self-Defense." October 2, 1877.

Courier-Journal & Times. "The Historic Homes of Kentucky. Number VII. White Hall, The Ancestral Abode of Gen. Cassius Clay, and Its Associations." January 29, 1899.

——. "Kentucky to Exorcise Ghosts of Whitehall's Unhappy Past." April 9, 1967.

——. "Whitehall's Restoration Is Viewed." October 17, 1971.

Daily Leader. "Cassius Clay: Opens Fire on Deputy Sheriffs and Fusilade Ensues." April 5, 1901.

——. "Holds the Fort Alone: Gen. Clay Is in Undisputable Possession of White Hall." April 8, 1901.

——. "Is Gen. Clay Wounded?" April 6, 1901.

Ellison, Betty Boles. *A Man Seen But Once: Cassius Marcellus Clay*. Bloomington, IN: Authorhouse, 2005.

Filson Club History Quarterly 46. "Biography of Cassius M. Clay: Written by His Daughter Mrs. Mary B. Clay" (1972): 254–55.

Fortune, Beverly. "The Past Comes Home for White Hall's Future." *Courier-Journal & Times*, April 5, 1970.

Fountain City Tennessee History. "Fountain City Places that Made a Difference—Botherum." http://www.fountaincityhistory.info/Places34-Woodward-WilliamsHouse.htm.

French Tipton Papers. Special Collections and Archives, Crabbe Library, Eastern Kentucky University, Richmond, Kentucky.

Harding, Margery Herberling. *George Rogers Clark and His Men: Military Records 1778–1784.* Frankfort, KY Historical Society, 1981.

Heflin, Donald L. *The Clay's of White Hall.* Richmond, KY: privately printed, 1994.

Historic American Buildings Survey. "White Hall." HABS no. KY-101, September 3, 1967.

Lancaster, Clay. *Antebellum Architecture of Kentucky.* Lexington, KY: University Press of Kentucky, 1991.

———. *Back Streets and Pine Trees: The Work of John McMurtry, Nineteenth Century Architect-Builder of Kentucky.* Lexington, KY: Bur Press, 1956.

———. "Major Thomas Lewinski: Émigré Architect in Kentucky." *Journal of the Society of Architectural Historians* 2, no. 4 (1952): 13–20.

———. "The Metamorphosis of Clermont into White Hall." *Kentucky Review* 7, no. 3 (1978): 5–28.

Lexington Herald. "Former Wife of General Cassius M. Clay Is Dead." February 14, 1914.

Lexington Herald-Leader. "Bodyguard's Notes Concerning Cassius Clay I Are Revealing." January 10, 1960.

Lexington Leader. "All Wills Void, Natural Heirs Will Get Estate of Gen. Cassius Clay—Miss Dora Brock Will Contest." April 14, 1904.

———. "Death Mask." July 26, 1903.

———. "Gen. Clay's Treasures." October 10, 1903.

———. "White Hall, Gen. Clay's Farm Sold to Warfield Bennett and Mrs. James Bennett." October 23, 1903.

Lexington Leader, from *Cincinnati Commercial Tribune.* "The Siege of White Hall." April 9, 1901.

Lexington Reporter. "Taverns to Rent." October 1, 1814.

Louisville Courier-Journal. "Happy with His Bride." November 15, 1894.

———. "Lonnie Clay's Arrival at Richmond." December 2, 1894.

———. "Peaceful End to the Life of Gen. Cassius M. Clay." July 23, 1903.

———. "Sage of Whitehall Spends His Days in a Lonely Room." July 12, 1903.

Louisville Courier-Journal & Times. "White Hall's Lion Is Back in His Lair." October 23, 1971.

Madison County Newsweek. "White Hall Restored: Saturday Night Candlelight Tours Will Be Conducted through September 15." Undated.

Martinson, Thomas R. *Historic American Buildings Survey: Whitehall.* HABS No. KY-101. White Hall State Historic Site Archives, Richmond, Kentucky.

McQueen, Keven. *Cassius M. Clay: Freedom's Champion.* Paducah, KY: Turner Publishing Company, 2001.

Morning Herald. "Will." July 25, 1903.

Mount Sterling Advocate. "The Famous Herd of Cassius M. Clay Southdowns." December 17, 1902.

————. "To Take Charge of the Person and Property of the 'Old Lion of White Hall.'" July 15, 1903.

National Register of Historic Places. "Kentucky—Madison County." http://www.nationalregisterofhistoricplaces.com/kymadison/state2.html.

New York Times. "Cassius M. Clay's Ready Pistol." October 2, 1877.

————. "Gen. Clay Divorced." September 10, 1898.

————. "Gen. Clay Weds Pretty Dora." November 14, 1894.

————. "Wants Child Wife Back: Gen. Clay Sends for Dora Clay Brock, Whose Husband Was Killed by a Train." July 1, 1903.

Nolan, Irene. "White Hall: Mansion with Violent, Romantic Past." *Courier-Journal & Times,* October 17, 1971.

Observer & Reporter. "Gen. C.M. Clay's Arrival and Reception." December 15, 1847.

Odem, Mary E. *Delinquent Daughters: Protecting and Policing Adolescent Female Sexuality in the United States, 1885–1920.* Chapel Hill: University of North Carolina Press, 1995.

Payne, Dale, ed. *Frontier Memories III: Rev. John Dabney Shane Interviews as Taken From the Draper Manuscripts.* Fayetteville, WV: privately printed, 2008.

Porter, Roy, and G.S. Rousseau. *Gout: The Patrician Malady.* New Haven, CT: Yale University Press, 1998.

Richmond Climax. "One of His Wills Was Written." October 21, 1903.

Richmond Daily Register. "Cassius Clay's Freedom Goal Stressed by Nunn." September 17, 1971.

Richmond Register. "Cassius M. Clay's Cannon in Tennessee." February 15, 1922.

San Francisco Call. "Aged General Clay Besieged by Women." March 31, 1898.

————. "General Cassius M. Clay Is Deprived of Weapons." July 15, 1903.

Schureman, Jerry O. "Cassius Clay's Decaying Mansion: Lionless White Hall Dying Slow Death." Publisher unknown, undated.

Schweder, Warren. "Whitehall, 153-Year-Old Mansion of Cassius Clay on 2,250-Acre Madison County Farm Almost in Ruins." *Lexington Leader*, May 31, 1951.

Smiley, David L. *Lion of White Hall: The Life of Cassius M. Clay*. Madison: University of Wisconsin Press, 1962.

Sunday Leader. "Dead Line: Placed by Gen. Clay and Death the Penalty for Crossing It." April 7, 1901.

Sutton, Carol. "Beula Nunn Winds Up Her 'Job.'" *Louisville Courier-Journal & Times*, December 5, 1971.

Tate, Sarah House, and Gregory Fitzsimons. "Initial Study for the Restoration of the Kitchen and Cook's Quarters at White Hall State Historic Shrine Madison County Kentucky." Undated. White Hall State Historic Site Archives, Richmond, Kentucky.

The Transylvanian 15, no. 9. "The Burning of the Main Building: The End of an Era" (1907): 452–54.

Unknown newspaper. "Grows Warm: The Discussion Between Gen. Clay and Dr. Fee." August 11, 1896. Available from White Hall Archives.

Unknown newspaper. "Madison Countians' Day: Whitehall Dedication Today." September 16, 1971. Available from White Hall Archives.

Unknown newspaper. "Public Sale." April 15, 1856. Available from White Hall Archives.

Wikipedia. "Clay County, Kentucky." http://en.wikipedia.org/wiki/Clay_County,_Kentucky.

LETTER COLLECTIONS

Bill Scott Collection. Archives and Special Collections, Margaret I. King Building, University of Kentucky, Lexington, Kentucky.

Esther Bennett Collection. Archives and Special Collections, Margaret I. King Building, University of Kentucky, Lexington, Kentucky.

J.T. Dorris Collection. Special Collections and Archives, Crabbe Library, Eastern Kentucky University, Richmond, Kentucky.

ABOUT THE AUTHORS

Lashé D. Mullins is the curator of White Hall State Historic Site. Lashé's history with White Hall dates back to her childhood, as members of her family have farmed the surrounding land for several decades. Lashé holds a master's degree in history and is a member of the Madison County Historical Society.

Charles K. Mullins is a former docent of White Hall. He is president of the White Hall–Clermont Foundation, a nonprofit organization dedicated to the preservation and continued support of White Hall. Charles holds master's degrees in theatre as well as recreation and park administration.

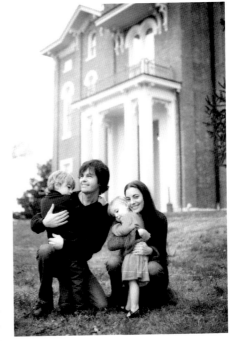

Visit us at
www.historypress.net